IMAGES
of America

THE 1939–1940
NEW YORK WORLD'S FAIR

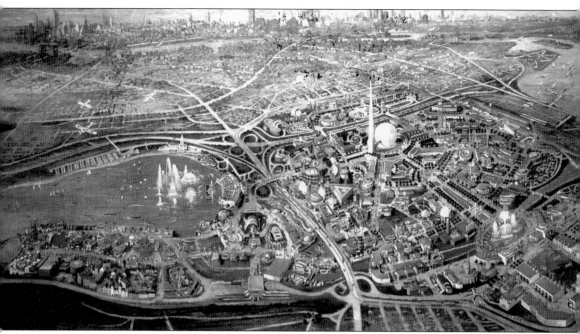

The wonders of the World of Tomorrow were captured in this prefair painting commissioned for use in the official guidebook and publicity materials. Titled *From Dump to Glory*, it was painted by H. M. Pettit using tempera paints on wallboard. The painting is now in the collection of the Portledge School in Locust Valley, New York.

IMAGES
of America

THE 1939–1940
NEW YORK WORLD'S FAIR

Bill Cotter

ARCADIA
PUBLISHING

Published by Arcadia Publishing
Charleston SC, Chicago IL, Portsmouth NH, San Francisco CA

Printed in the United States of America

Library of Congress Control Number: 2008940551

For all general information contact Arcadia Publishing at:
Telephone 843-853-2070
Fax 843-853-0044
E-mail sales@arcadiapublishing.com
For customer service and orders:
Toll-Free 1-888-313-2665

Visit us on the Internet at www.arcadiapublishing.com

CONTENTS

Acknowledgments 6

Introduction 7

1. Creating the World of Tomorrow 9

2. The Theme Center 15

3. The Transportation Zone 25

4. The Communication and Business Systems Zone 39

5. The Food Zone 45

6. The Government Zone 55

7. The Community Interests Zone 79

8. The Production and Distribution Zone 87

9. The Amusement Area 101

10. The 1940 Season 113

ACKNOWLEDGMENTS

Although I have been collecting photographs and information from the fair for many years, many parts of this grand venture are still waiting to be discovered or analyzed. It is always fun to turn up something new, but sometimes it is difficult to properly identify where a picture was taken, which season it was from, or perhaps even what the subject was. Fortunately, I have received a great deal of help in answering these and other questions from Eric Keith Longo, whose knowledge of the fair is encyclopedic in scope.

I also received invaluable assistance from my wife, Carol. Sometimes an author can get too close to his subject and assume that others know it as well as he does. Carol has helped me on countless occasions by asking just what point I was trying to make, and her proofreading skills have saved me from many an embarrassing error.

All photographs are from the author's collection.

This book is dedicated to Mom and Dad. Thanks for kindling my interest in the fair by sharing your memories of your own trips there. And yes, Mom, I did remember to get the Italy pavilion in here for you. And to Carol, thanks for continuing to indulge my mania for collecting photographs from the past.

INTRODUCTION

I was introduced to world's fairs at the age of 12 during the first season of the 1964–1965 New York World's Fair. I had heard about the 1962 fair in Seattle, and an aunt had been to Expo 58 in Brussels, but as far as I was concerned the 1964 fair was *the* fair. I doubt if I was even aware that an earlier fair had been held on the same site, and I probably had never heard of the Trylon and Perisphere.

After college I moved to Los Angeles to work in the entertainment industry, an interest driven in large part by the 1964 fair. My parents were still in New York, and on one visit home I went back to Flushing Meadows to see what had become of my beloved fair. My mother joined me, and as we walked around the grounds she kept mentioning the 1939 fair. When we got home she gave me her old guidebook to the fair. Little did she know that she had kindled a major new interest in me.

Things really started taking off in 1989 on another trip to New York, this time for a world's fair show at the Queens Museum of Art on the old fair site. I had gone there primarily to add to my collection of 1964 memorabilia, but there were several presentations on the 1939 fair. Watching films of the fair and browsing through the merchandise on sale increased my appreciation of the 1939 edition.

Shows like this and other opportunities to meet with people who had been at the fair provided an interesting perspective on the event. While these past visitors were unanimously positive about the fair, most of them could not recall any significant exhibits other than General Motor's Futurama or Billy Rose's Aquacade. When asked what other exhibitors such as Ford or General Electric had shown, though, most people had no definite or accurate response.

What, then, was it that these people did remember? It was the fair's style, beauty and, most of all, the optimistic outlook it offered for the future. This was a major revelation for me; as a baby boomer, it was hard to understand the climate that had existed during the 1939 fair. The 1964 fair had taken the position that the 1950s were good but the future was going to be even better. Cars would be faster, houses easier to clean, and technology was going to have us vacationing on the moon or under the sea. In 1939, though, many people did not own cars, could only dream of owning a house, and if they were very lucky, a vacation was a few days at a lake or sitting by the ocean.

To really appreciate the 1939 fair, then, means that one has to understand the feeling of promise and hope it offered to those who had been through the Great Depression. Exhibits such as Futurama or Democracity predicted that home ownership would be the standard rather than an exception, and even better still, almost everyone would live in the suburbs, away from the noise and congestion of the cities. These happy views of the future were presented in an

imaginative setting, an oasis from everyday life that was full of strangely shaped buildings, colorful flowers, sculptures, and fountains. Almost everyone I have spoken to about the fair has talked much more about the fair as a whole than of any specific exhibit or show.

This is the fair I wanted to recreate in this book. Over the years I have continued to increase my collection of material from the fair, and while much of it is the standard souvenir items common to such expositions, my favorite acquisitions have been candid photographs. They are the closest I will ever get to see the fair myself. They are also a more accurate way to see what made the fair so special than is otherwise available through news stories of the time or today's history books. There have been several excellent books about the fair over the years, but they have focused on the official publicity photographs taken by the fair corporation and its exhibitors. Most of those pictures appear to have been taken while the fair was under construction or closed to the public, with generally stark views of empty pavilions and streets. While these provide a wonderful way to study the details of the fair, they do not convey the energy and wonder experienced by those lucky enough to have been there.

The candid photographs that make up the majority of this book feature scenes of guests as they stroll the grounds and take in the shows, or document the views that they felt were important at the time. This includes the gardens and sculptures instead of some of the decidedly dull interior exhibits; the Consumers Building, for example, had displays on items such as foot powder and butterfly-wing jewelry, which were quickly dropped from consideration for inclusion. In some cases I had to use publicity photographs for angles the average visitor could not have taken, such as aerial views, but these pictures total approximately 12 of the more than 200 images presented here.

With its hundreds of buildings, statues, and exhibits, it is impossible to capture the entire fair in any one book. I hope these vintage scenes, though, have caught some of the beauty and magic that made up this wonderful "World of Tomorrow."

—Bill Cotter, www.worldsfairphotos.com, December 2008

One

CREATING THE WORLD
OF TOMORROW

*The eyes of the Fair are on the future—not in the sense of peering into the unknown and predicting
the shape of things a century hence—but in the sense of presenting a new
and clearer view of today in preparation for tomorrow.*
—*Official Guide Book of the New York World's Fair 1939*

The 1939–1940 New York World's Fair began, as so many grand projects do, as a way to make money. Chicago's Century of Progress exposition, which had opened in 1933, was so successful that it returned for a second season. The positive international press, and more importantly the resultant tourist dollars, resulted in several studies across the country on the feasibility of other world's fairs.

In New York, the effort started in 1935 with a small group of seven business leaders and politicians, led by George McAneny (a prominent banker and politician), Grover Whalen (the city's former police commissioner), and Percy Selden Straus (president of R. H. Macy and Company). That fall they hosted a meeting for 121 influential executives and politicians and presented glowing projections of the profits that would result from the fair. Their estimates envisioned 40 million visitors in a single season and another 24 million possible if a second year was added. The enthusiastic response to this meeting led to the formal creation of the fair corporation, led by Grover Whalen. Sixteen Manhattan banks loaned $1.6 million to start the project, and by the time the gates opened, spending had reached $156,905,000.

The fair was ostensibly tied to the 150th anniversary of George Washington's presidential inauguration in 1789 in New York City, which was then the nation's capital. This link was suggested by civil engineer Joseph Shadgen, who is also credited with suggesting the fair's location. The site chosen was a desolate landfill in the borough of Queens, described by F. Scott Fitzgerald in *The Great Gatsby* in 1925 as a "valley of ashes." With the enthusiastic backing of the city's park commissioner, Robert Moses, and Mayor Fiorello La Guardia, work began on transforming the dump into a site suitable for a world's fair. The project included more than 62 miles of roads, 200 buildings, 10,000 trees, 2 million shrubs and bushes, exhibits by 58 nations and 33 states, 76 concessionaires, 1,354 exhibitors, and 310 places to eat. The fair opened on April 30, 1939, inviting the world to explore its theme, "Building the World of Tomorrow with the Tools of Today."

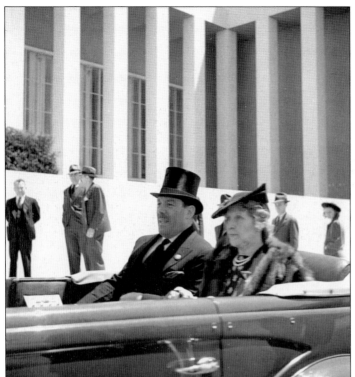

The fair's president, Grover Whalen, pictured on the left with an unidentified woman, promoted both the event and himself at every available opportunity. A consummate showman, he was frequently seen escorting VIPs around the fair, always impeccably attired. While some press accounts criticized Whalen for his self-promotion, he more than succeeded in getting the fair into the local and national news, thus establishing it as an important international event.

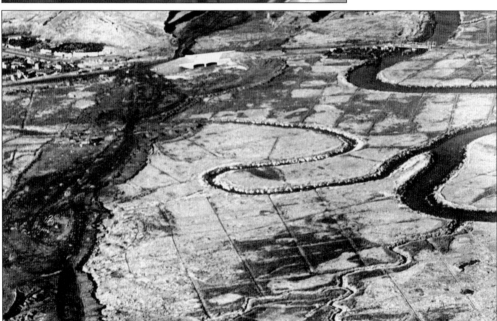

Flushing Meadows offered the designers a blank canvas, but it also posed some staggering challenges. The site had none of the infrastructure needed for the fair, such as plumbing or electricity; a river would have to be diverted; and decades worth of trash would have to be hauled away or compacted. All this would have to be done in less than four years to have the site ready for opening day.

Seeking to avoid a clash of conflicting architectural styles and colors, the fair corporation formed a design committee that had the final say over the design of the pavilions and landscaping. Each exhibitor was required to submit a detailed concept painting, such as this one for the Beech-Nut building. The committee then ruled on the design as well as the building's placement on the site.

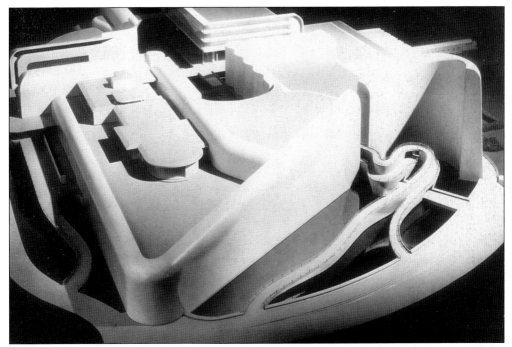

This model of the General Motors pavilion illustrates the next step in the design process. These miniature pavilions were built in various sizes, with the smallest versions used on a master model of the site for advertising purposes. Larger ones helped to refine the designs before the final blueprints were drawn and construction could begin. Very few of these models survive today.

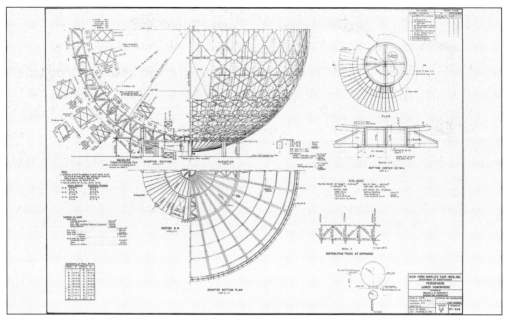

Structures like the Perisphere required hundreds of detailed blueprints. Without computers to aid them, the designers had to rely on slide rules and other traditional tools, making the design of these unique structures even more challenging. Nothing was left to chance; this blueprint shows that the Perisphere's base was designed to support 370,000 pounds of snow in addition to the building's weight of more than nine million pounds.

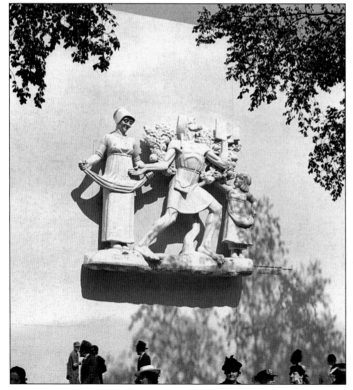

The fair corporation buildings were constructed without windows, greatly increasing the amount of exhibit space inside and easing cooling. This left large exterior areas suitable for decoration with murals, friezes, decorative lighting, and other treatments. Artists competed to showcase their work, such as Edmond Amateis's relief *Benevolence* (featuring Johnny Appleseed), seen here on the Medicine and Public Health Building.

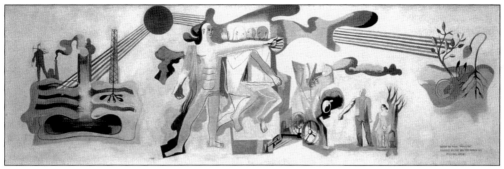

Other artists won commissions for the dozens of murals that graced both the exteriors and interiors of many of the pavilions. Preliminary sketches, such as this one titled *Production* by Michael Loew for the Pharmacy Building, helped designers ensure the finished murals would fit in with the rest of the exhibits and get the all-important approval from the fair's design committee.

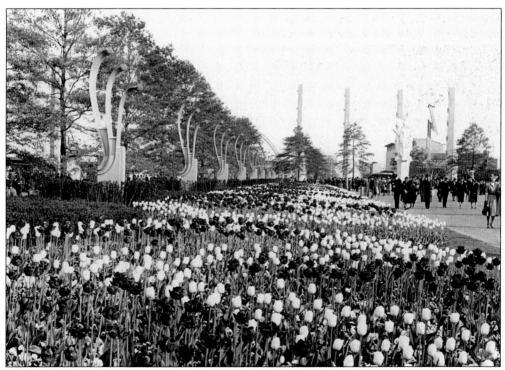

The fair corporation further brightened up the site with the addition of $1.5 million of landscaping. By opening day, the grounds sported 10,000 trees, 400,000 pansies, 500,000 hedge plants, 1 million bulbs, and 1.5 million bedding plants. These tulips on the Court of Power were just a small part of the colorful displays that were updated and refreshed throughout the year.

The Administration Building opened in August 1937. Viewed across the Grand Central Parkway from the extreme northern end of the Transportation Zone, the complex also included the fair's press office, postal facilities, and a restaurant used to entertain official guests. Senior fair executives had their offices here, and a smaller facility in the Production and Distribution Zone, the Operations Building, was used to control the daily functions of the fair.

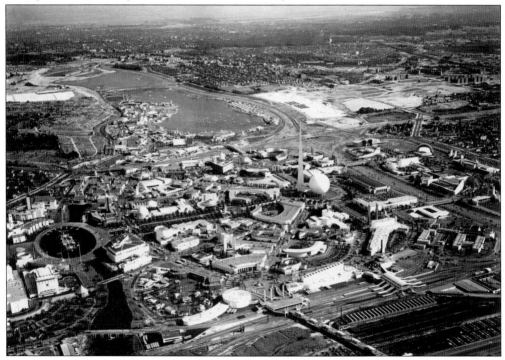

Just four years earlier, this was a giant trash heap populated only by rats. Stretching across the 1,216.5-acre site, the fanciful buildings of the 1939–1940 New York World's Fair must have appeared as strange to visitors as the Emerald City of Oz did to Dorothy. It is interesting to compare the radial design visible in this aerial with the Democracity diorama inside the Perisphere.

Two

THE THEME CENTER

For miles around and from every point on the site, your attention
is arrested by the towering Theme Center.
 —*Official Guide Book of the New York World's Fair 1939*

In creating their world of the future, the fair's designers divided the Flushing Meadows site into several themed zones. Instead of a random mixture of pavilions spread across the site, themed zones allowed visitors to know in advance what section of the fair they wanted to explore. A trip to the Food Zone, for example, was sure to attract those looking to learn more about the subject.

In the center of the zones was the Theme Center. Like the hub of a wheel, the Theme Center tied together the zones that radiated out from it into one cohesive design. Hoping to create a structure as memorable as the Eiffel Tower, which had been built for the Universal Exposition of 1889, the planners considered a wide range of designs. Some were rejected as too unimaginative; others were too abstract; and still others were too expensive or impossible to build. The design that was finally selected consisted of two very simple geometric shapes—a triangle and a circle.

Those were the basic shapes of the Trylon and Perisphere. The two unusual structures loomed far above the other buildings of the fair and were visible from as far away as Manhattan and the Bronx. The designs were very popular and were licensed for use on an estimated 25,000 products. Licensing such as this was a relatively new concept, but a good one, for it earned the fair $1 million in the first season alone.

The Trylon and Perisphere were designed by Wallace K. Harrison and Jacques-André Fouilhoux. The design called for the massive Perisphere to be balanced on eight relatively small pylons, a feat that required some very imaginative work in those precomputer days. Strategically placed fountains masking the mirrored supports created the illusion that the orb was weightless, rotating on the jets of water underneath. At night, moving images of clouds were seamlessly projected from nearby exhibit buildings using glass-mounted slides to complete the effect, making views of the two structures memorable indeed.

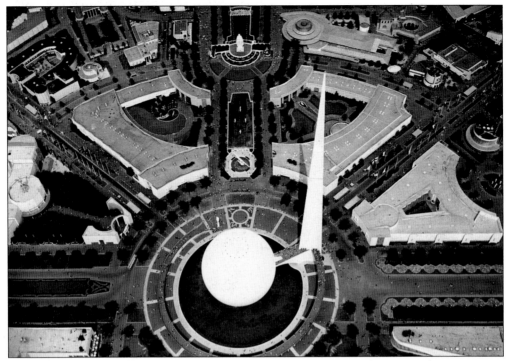

Viewed from any angle, the Trylon and Perisphere were a striking combination. The contrasting geometric shapes and stark clean lines made for a simple design, but the actual structures were engineering marvels. This view features Constitution Mall, the main axis of reflecting pools and sculpture that bisected the fair and led to the Lagoon of Nations. On either side are the Court of Communications (left) and the Court of Power (right).

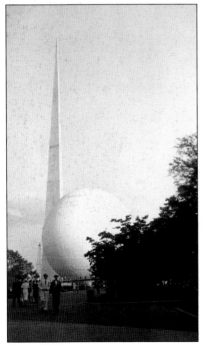

The theme structures were easy to see from anywhere on the fair site, which helped visitors orient themselves in the maze of streets and walkways. The Perisphere was 18 stories tall and 180 feet in diameter, with a circumference of 628 feet. At a height of 610 feet, the Trylon was the tallest structure at the fair.

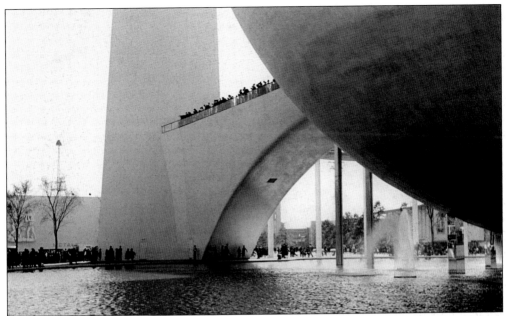

The original plans for the Perisphere called for a smooth concrete surface, but because of rising costs a less expensive composite covering of gypsum was used instead. Despite the best efforts of all involved, the finished structure had an uneven texture and some noticeable seams. The fountains under the Perisphere had to be lowered when it was found that they were damaging the relatively fragile gypsum covering.

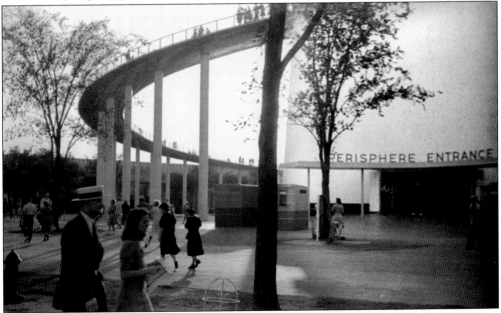

The Trylon and Perisphere were visible for miles. It was only natural that they would attract sizeable crowds, but anyone wanting to get a closer look inside the Perisphere had to pay a rather steep 25¢ admission fee. After they traveled up the longest escalator in the world, they entered an exhibit area more than twice the size of Radio City Music Hall. This was the home of the futuristic Democracity.

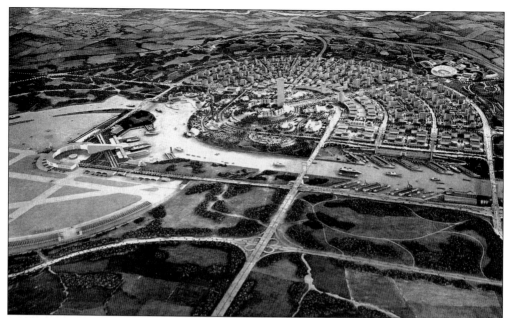

Democracity was viewed from two rotating balconies, dubbed "the Magic Carpet," that circled the model every six minutes. As the recorded narration explained the wonders of the futuristic city, the lights dimmed for the evening portion and phosphorescent paint made it look as if the miniature buildings were lit from within. The narration was accompanied by the theme song "Rising Tide" by William Grant Still.

Guests exiting the Perisphere onto the 65-foot-high Observation Platform usually found themselves in a natural wind tunnel, making it necessary for these ladies to hang tightly onto their hats. The dress code in 1939 was obviously far different than what one encounters in today's theme parks. Most men and women wore hats, and women in pants were quite the exception. In fact, many wore gloves and other pieces of their Sunday best.

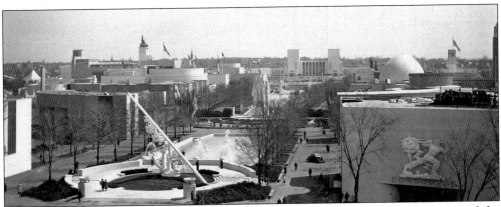

The Observation Platform offered an impressive view of Constitution Mall looking toward the Government Zone. Stretching 2,000 feet from the Theme Center toward the Lagoon of Nations, with the Federal Building rising in the distance, the mall was lined with hundreds of trees that framed five reflecting pools. Some of the fair's largest exhibit halls were located on either side of the mall, making this one of the busiest thoroughfares on the site.

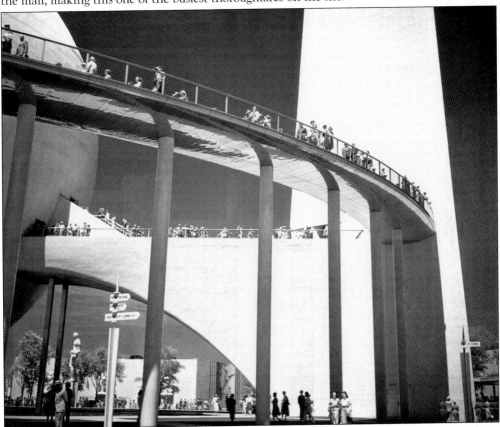

While the Trylon, the Perisphere, and the connecting bridge called the Observation Platform are well known, there was actually another component of the structure. The Helicline was a 950-foot-long, 18-foot-wide curved ramp that gracefully led visitors back down to ground level after their visit to Democracity. The mirrored underside of the Helicline was a distinct contrast to the matte white surfaces of the surrounding structures.

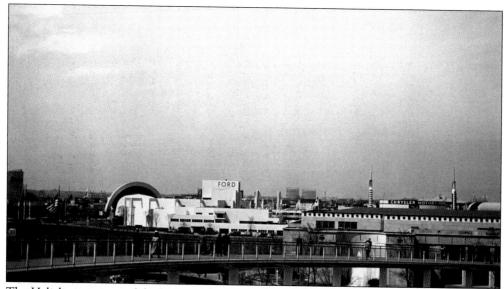

The Helicline was one of the highest open-air areas at the fair and a favorite spot for sightseers and photographers. This view toward the Transportation Zone shows the circular roof of the Aviation Building to the left of the Ford Road of Tomorrow pavilion. The two spires to the immediate right of Ford mark the Corona Gate South entrance to the fairgrounds; the larger spires mark the Chrysler Building.

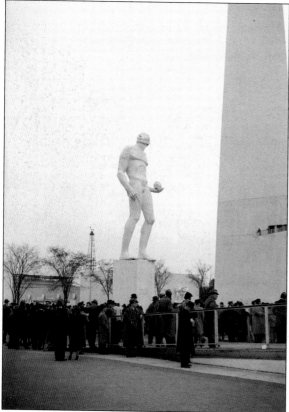

At the base of the Helicline guests passed by *The Astronomer* by Swedish American sculptor Carl Milles. The figure is holding a dodecahedron, an ancient Greek representation of space and the elements. The plaster statue was destroyed at the end of the fair, but several smaller bronze versions still exist.

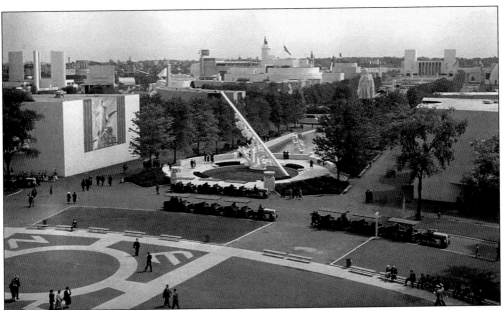

Among the most photographed sculptures at the fair was this giant sundial located at the end of Constitution Mall closest to the theme structures. Titled *Time and the Fates of Man*, it was designed by Paul Manship, who is famous for *Prometheus* at Manhattan's Rockefeller Center. The sundial was destroyed at the end of the fair, but smaller copies can be found in several collections today.

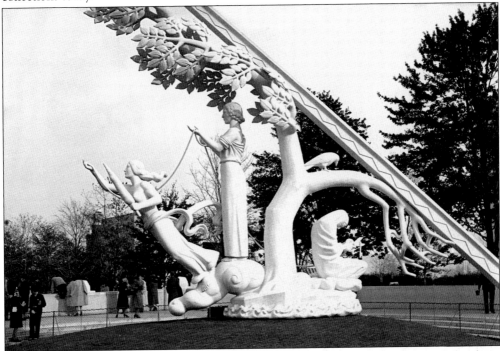

The sundial stood 80 feet tall and was the largest one in the world. It depicted the Fates, daughters of the goddess of necessity, under the Tree of Life, and the thread represented the stages of life as they wove, measured, and cut it. The god Apollo looks on in the guise of a crow.

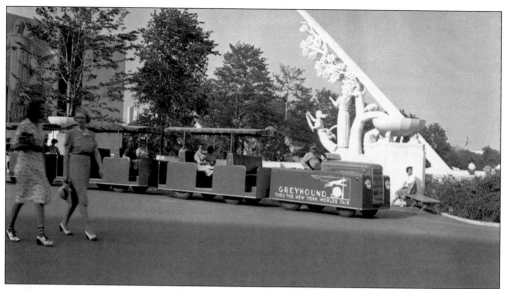

Paul Manship's sundial is seen here behind Greyhound's "trackless train." The one-way fare of 25¢ was a bit steep considering that admission to the fair itself was only 75¢, but the combination of a 1,216.5-acre site and weary feet created a steady stream of customers. Greyhound and American Express also offered smaller powered carts, hand-pushed trams, and full-sized buses as other ways to see the fair in comfort.

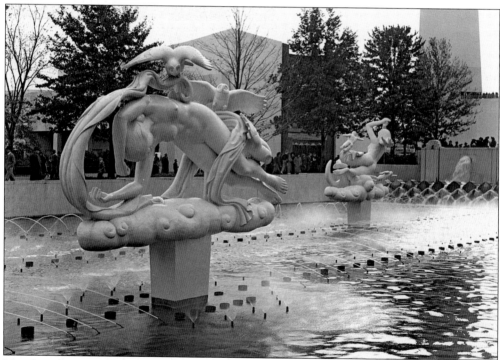

Manship also created the *Moods of Time*, a group of smaller figures surrounded by fountains at one end of Constitution Mall. The figure in the foreground is *Evening*, and others were *Morning*, *Day*, and *Night*. The water from the fountains weakened the plaster figures, and by the 1940 season, they had to be propped up by unsightly metal rods.

Freedom of Press was one of the *Four Freedoms* statues created by sculptor Leo Friedlander. The other 33-foot-tall statues were *Freedom of Speech*, *Freedom of Religion*, and *Freedom of Assembly*. Although it looks as though it was carved from stone, the statue was made of much more fragile plaster of paris and was destroyed after the fair.

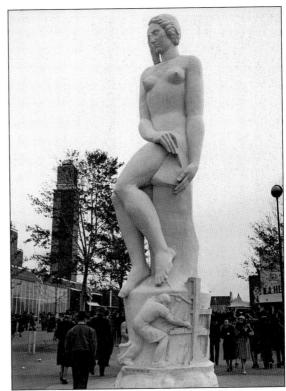

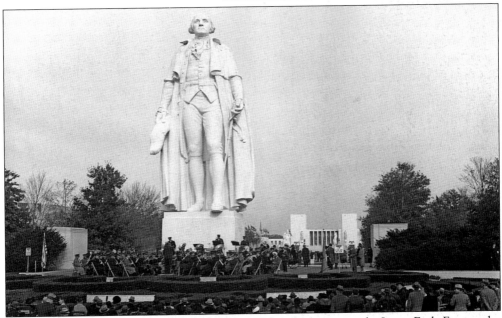

The largest figurative statue at the fair was this 65-foot-high creation by James Earle Fraser, who is perhaps best known for his design of the Indian-head nickel. So large that it had to be built in sections and assembled on site, it depicted George Washington in formal robes for his 1789 presidential inauguration in New York. The base was a popular setting for formal concerts, such as the one pictured here.

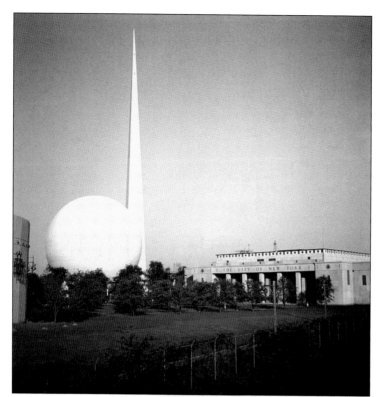

The New York City Building, which still exists today as the Queens Museum of Art, provided an unusual view of the workings of the city's government, for Mayor Fiorello La Guardia moved his office there during the fair. Other exhibits featured displays from various city departments, such as *Murder at Midnight*, which showed how the New York Police Department used scientific methods to solve crimes.

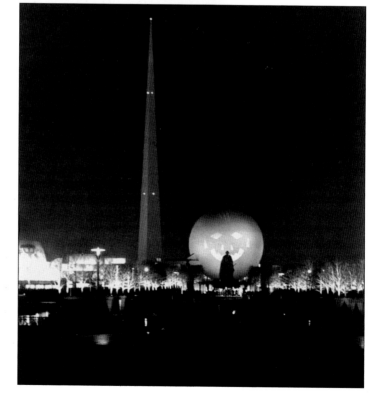

The large white surface of the Perisphere made it a natural canvas for special lighting displays. On the Fourth of July, for example, the massive globe was bathed in red, white, and blue stripes. This view showing it decorated as a giant jack-o'-lantern on Halloween was bittersweet. It marked the final day of the 1939 season, and no one knew if the fair would return for a second season.

Three

THE TRANSPORTATION ZONE

The Transportation Zone is devoted to many of the extraordinary inventions which have enabled Man to conquer time and space. The world has steadily grown smaller, its people ever closer together by improved methods of transportation.
—*Official Guide Book of the New York World's Fair 1939*

One of the most popular areas at the fair was the Transportation Zone. While today a traveler can easily be on the other side of the world in hours, in 1939 travel was a much more time-intensive effort. Trains were the standard form of transportation between cities, and most international trips were by steamship. These forms of travel were very popular, though, as evidenced by the legions of young boys who built model train sets or the crowds that celebrated the departure of ships full of happy passengers.

The transportation industry was at a virtual crossroads, though, for air travel was becoming more common and the first early highways were making automobile travel easier. The railroad industry saw the fair as a way to reinforce its message that trains were still the best way to travel, so a number of the lines joined together to build the fair's largest exhibit.

As popular as the railroad display was, it had serious competition from the automobile industry. After years of depressed sales due to the Great Depression, the industry wanted to convince the public that they could once again afford to buy a new car. Each of the country's three major car companies was at the fair, and they spared no expense in extolling the virtues of traveling in the comfort of one's own car. All the pavilions showcased their latest products, but the favorite displays for many were the often-elaborate depictions of futuristic cars, highways, and cities.

With the massive infusion of cash required to build these pavilions, the Transportation Zone was a showcase of the strength of American industry. The money was well spent, for the area was attended by large crowds eager to see the newest ways to travel. This was especially true at General Motors, which was the most popular pavilion at the fair due to its prediction of the future in the Futurama ride.

Most of the fair's predictions for the future have yet to appear, especially computerized highways and planned cities. One major prediction did come true, however, for the automotive industry did, indeed, surpass the railroads.

The Corona Gate South, one of the main entrances to the fair, led directly into the Transportation Zone. Admission prices in 1939 were 75¢ for adults and 25¢ for children ages 3 to 14. A variety of other discounted tickets and packages was also available, including annual passes for $15 and $5, respectively.

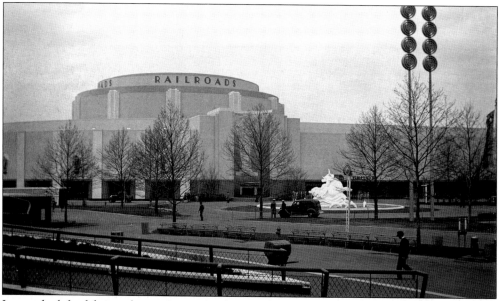

Just to the left of the south entrance turnstiles was the Eastern Railroads Presidents' Conference building, better known as the Railroads pavilion. Railroads were still the major form of transportation throughout the country, and the industry turned out in force. Twenty-seven railroads joined together in the largest building at the fair.

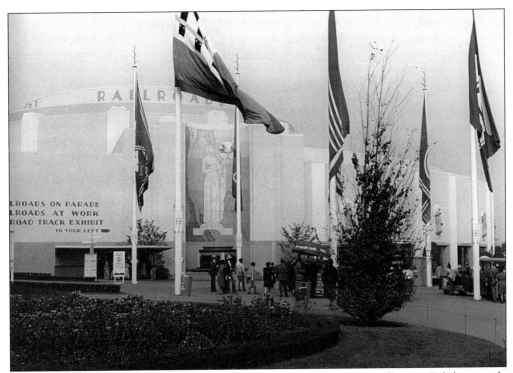

The shape of the Railroads pavilion was suggested by an engine roundhouse. Exhibits inside included one of the largest model railroad dioramas ever built, which featured 50 locomotives pulling more than 500 pieces of rolling stock, and an equally elaborate display on the building of railroads.

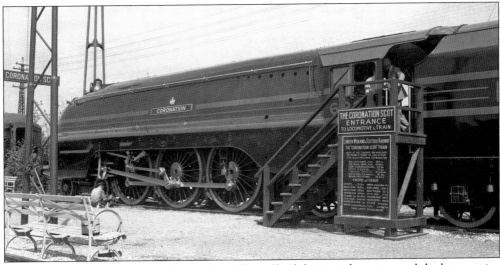

The fair was a train lover's paradise, with exhibits of both historical engines and the latest trains from around the world. It took a great deal of work to bring these trains to the fair. For example, Great Britain's *Coronation Scot* was 580 feet long and weighed almost 500 tons.

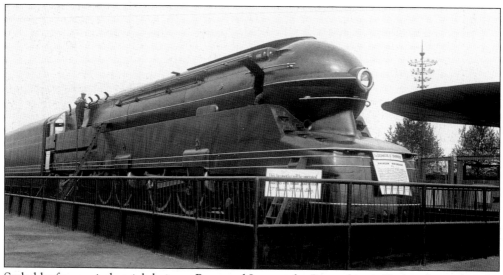

Styled by famous industrial designer Raymond Loewy, the Pennsylvania Railroad's massive S-1 locomotive was the largest rigid-frame passenger locomotive ever built. Billed as the "Locomotive of Tomorrow," the S-1 proved to be too large for most tracks, and it was scrapped in 1949.

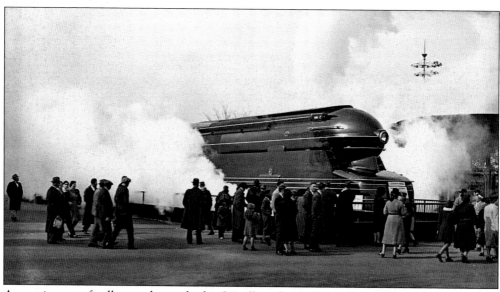

A massive set of rollers underneath the S-1 allowed it to be run at full speed several times each day to let crowds see and feel the power of the 300-ton behemoth up close. In today's more safety-conscious world, it is unlikely that crowds would be allowed to get that close to a working locomotive.

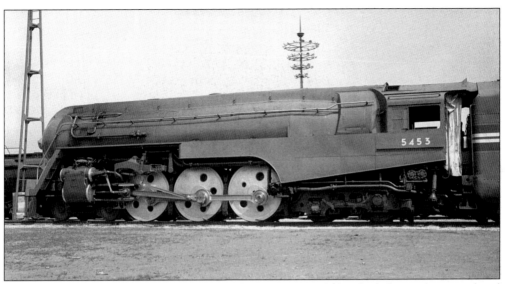

The New York Central displayed its Hudson-class engine No. 5453, which featured a streamlined design by Henry Dreyfuss. The Hudson class was used to pull the line's *20th Century Limited* between New York City and Chicago. This particular engine was very popular with train enthusiasts and is available today in model railroad form.

The highlight of the train displays was *Railroads on Parade*, an ambitious stage show played out in a 3,000-seat theater. A cast of 250 performers recreated key moments in transportation history, but the real stars were actual locomotives and other rolling stock. Vintage engines were gathered from museums and storage yards and restored to operating condition, with modern replicas used to recreate those lost to time.

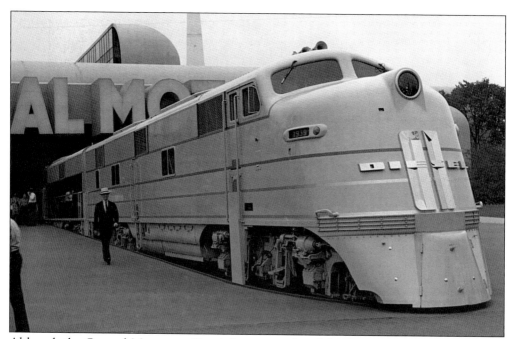

Although the General Motors pavilion is best remembered for the Futurama ride, there were also displays of the company's other products, such as this diesel locomotive, as well as exhibits on the company's manufacturing processes and Frigidaire division. Rail travel was at its peak during the fair, and diesels were just beginning their eventual dominance over steam engines.

The high point of the General Motors pavilion, and for many of the whole fair, was Futurama, an optimistic prediction of life in 1960. The massive model offered the promise of clean, open cities surrounded by suburbs with large expanses of green space, all connected by automated highways. Freed from the need to do the actual driving, future motorists could enjoy the scenery on highways that crossed previously impassable mountains and deserts.

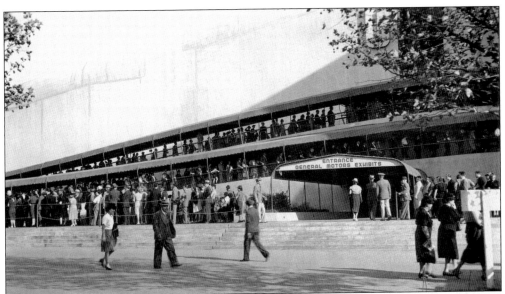

The popularity of Futurama surpassed even the most optimistic projections made by the General Motors marketing staff. Long lines such as this were the norm, so early-morning visitors often raced there as soon as the fair opened in hopes of avoiding the wait. On the busiest days the line became so long that it wrapped around the pavilion and back on itself, but the crowd kept coming back for more.

After guests had seen Futurama, they exited outside into a full-sized display that mirrored an intersection that they had just seen in small scale. The designers predicted that future cities would carry pedestrians on walkways above the traffic, thereby speeding up vehicle flow and making it easier to load and unload merchandise. How a design like this would be incorporated into existing city architecture was a detail that was apparently overlooked.

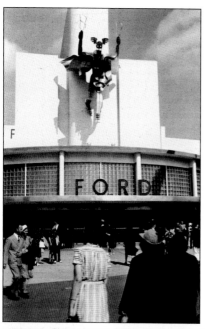

While not as well known as General Motor's Futurama, Ford also had a major exhibit. As guests entered the pavilion, they passed underneath a stainless steel "ribbon" sculpture of Mercury crafted by Robert Foster. The exhibit hall featured the Quadricycle, Henry Ford's first car; a 1903 Model A; and the company's latest models.

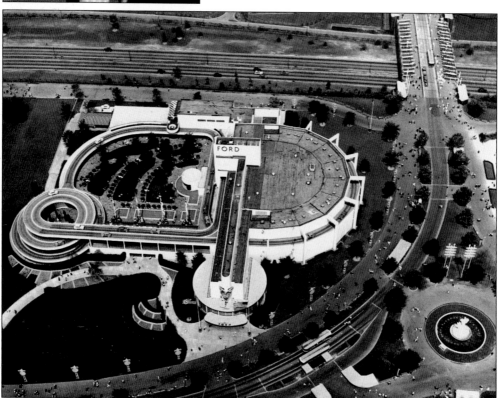

The Ford pavilion's main feature was the spiraling Road of Tomorrow, a half-mile-long curving roadway where guests were driven through displays of Ford products in chauffeured comfort. The pavilion also included an outdoor stage with gardens and fountains, making it a popular concert site despite the noise of the passing cars.

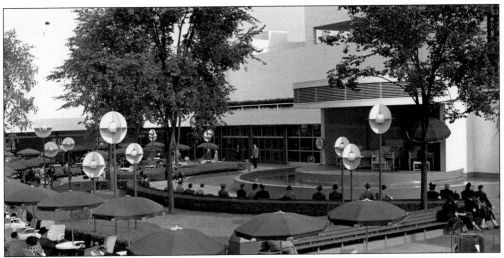

Ford's stage was located in the Garden Court, where entertainment was provided by Ferde Grofé and his New World Ensemble. The act was based on a newly invented instrument called the Novachord, a Hammond instrument that could simulate a piano, harpsichord, banjo, steel guitar, and other reed and string instruments.

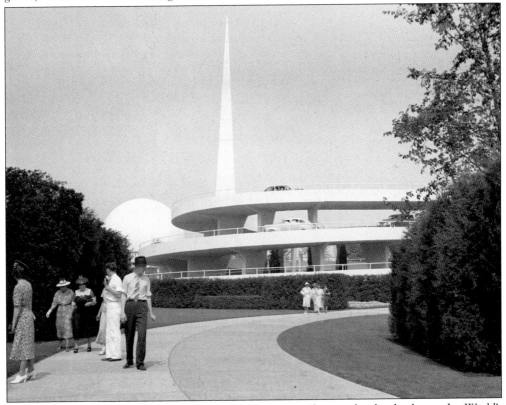

Henry Ford, a firm believer in the value of world's fairs, often credited a display at the World's Columbian Exposition of 1893 as the inspiration for his first gasoline-powered engine. Ford spent $5,528,246 on the pavilion for the two years of the fair, a very impressive amount in 1939 dollars.

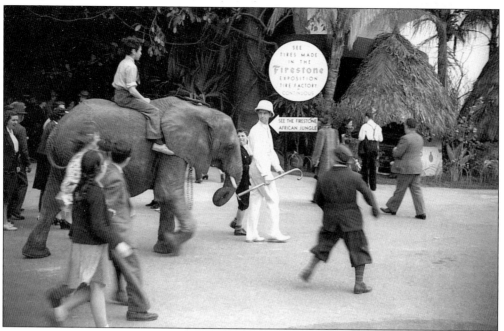

Where else but a place as wonderful as a world's fair could a young boy enjoy a ride on an elephant? Those not lucky enough to get a ride could instead visit the Firestone exhibit in the background where they would learn about rubber plantations and watch raw rubber being turned into a tire. Guests could even buy the new tires, which were produced every four minutes.

The Firestone pavilion also included a full-sized farm to show how air-filled tires benefited all aspects of modern farming. Live animals roamed the site, with a mix of live performers and mannequins demonstrating the many jobs on a farm. Young visitors could also volunteer to drive a tractor under the watchful eye of a pavilion host.

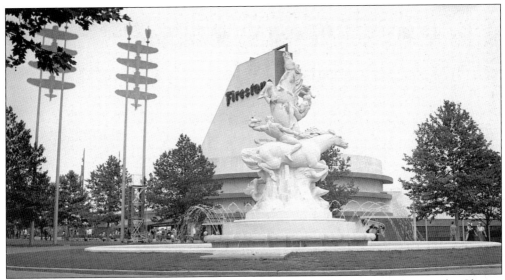

The Firestone pavilion provided a dramatic background to *Riders of the Elements,* by Chester Beech. The statue featured horses and riders conquering the elements of air, earth, and wind, and light fixtures with formations of airplanes rose into the air representing the mastery of speed.

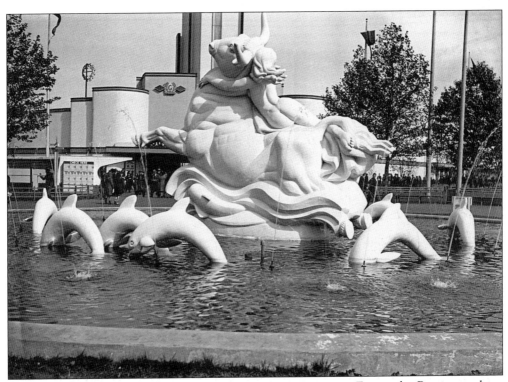

Another of the major statues in the Transportation Zone was *Europa,* by Russian sculptor Gleb W. Derujinsky, who described it as an allegorical depiction of power. The statue featured Jupiter, who had transformed himself into a white bull, carrying a Phoenician princess in the company of frolicking dolphins.

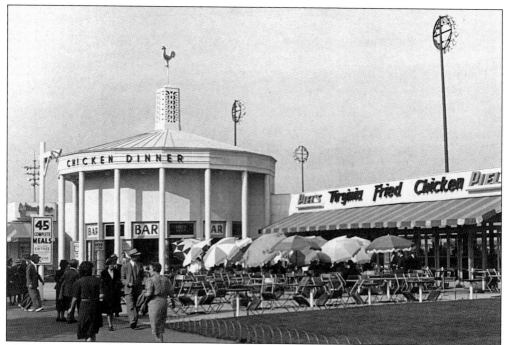

Hungry visitors could pause for a meal at this Piel's restaurant, one of two the company operated at the fair. Diners enjoyed a complete meal, including an entrée, beverage, and dessert, for only 45¢. Piel's was a popular local brewery, and the restaurant offered cold beers for 10¢.

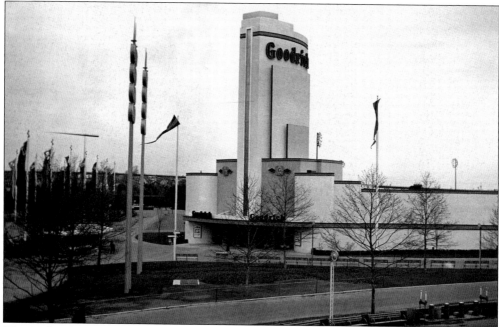

The 90-foot-high tower at the entrance to the Goodrich pavilion housed an unusual display dubbed the "tire guillotine," a massive steel blade that was dropped onto a stack of tires to demonstrate their strength and construction. Other exhibits included a futuristic car made of rubber and examples of Goodrich's latest manufacturing processes.

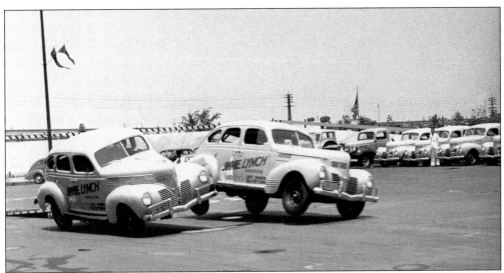

The most popular part of the Goodrich pavilion was the Goodrich Safety Arena, where Jimmy Lynch and his Death Dodgers stunt drivers entertained crowds six times each day. The act included demonstrations of Goodrich's Silvertown tires on a special section of the track that could be flooded to simulate wet roadways.

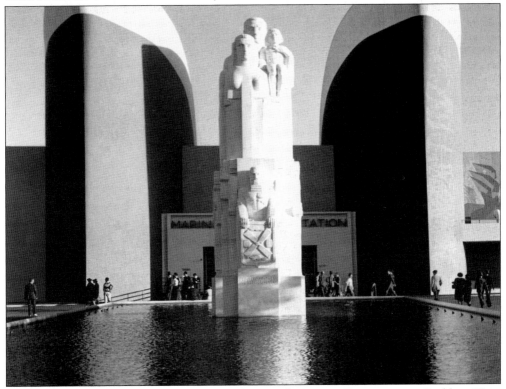

One of the more striking exhibit halls at the fair was the Marine Transportation Building. Twin prows, standing 80 feet in height, spanned the entranceway. A reflecting pool holding the statue *Manhattan* by Sidney Waugh added to the nautical motif. Inside, radio reports were used to update a giant map of the world showing the locations of American shipping.

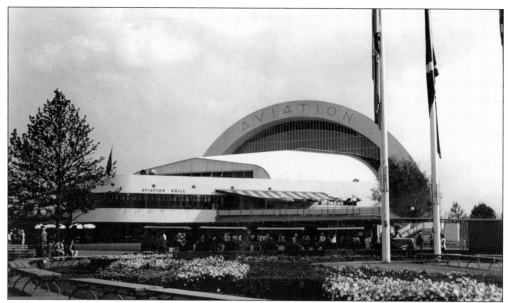

The world of flight was on display in the massive Aviation Building. The front portion was styled after a passenger terminal, and the rear was said to represent a plane or dirigible entering a hangar. Displays inside explained the basic principles of flight and aerial navigation, with an emphasis on recent advances that made air travel safer and more affordable.

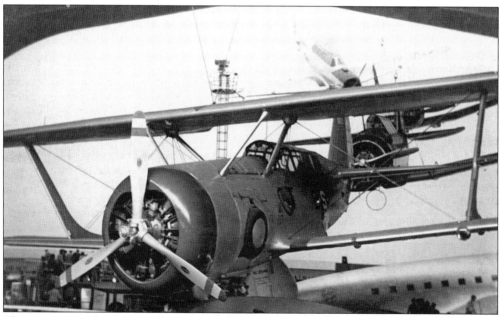

The most unusual exhibit at the Aviation Building was this formation of military planes that appeared to be diving into the pavilion's hangar-shaped entrance. Other aircraft were also on display, including some of the latest American passenger and military planes, several of which were open for tours. The Aviation Bar and Grille was a popular spot for dinner or a drink.

Four

THE COMMUNICATION AND BUSINESS SYSTEMS ZONE

Modern civilization is based on Man's ability to receive knowledge, sentiments, ideas; the "World of Tomorrow" will largely be shaped by his ability, as well as his desire, to communicate.
—Official Guide Book of the New York World's Fair 1939

In today's world of near instant communication to almost any part of the globe it may be difficult to realize how far things have come since the days of the fair. In 1939, many homes did not have a telephone, and for those that did, they may have had to share a party line with their neighbors. Long-distance calls required help from the always-efficient operator, as did even local calls in smaller towns. There were hardly any television sets in the entire world, and radio was the primary form of broadcast communication.

The tools of business were quite different as well. There were no computers, although IBM was already selling card-sorting systems that formed the basis of the accounting systems in many large businesses. There were no fax machines, no videoconferencing, and no pagers. So, then, what projections did the fair have in these areas for the world of tomorrow?

In this period, the peak of radio and the early dawn of television, there were not very many visible advances in comparison to exhibits in the other zones. Most of the exhibits in this zone, the smallest at the fair, were rather pedestrian displays of encyclopedias, children's books, typewriters, bank vaults, and mimeograph machines. The major points of interest were at the Radio Corporation of America (RCA) and American Telephone and Telegraph (AT&T) pavilions, where demonstrations of the latest advances in communications attracted steady streams of visitors. The fair was the first opportunity for most people to see a working television set, to use a tape recorder, or to make a long-distance telephone call.

There was one major form of communication that was overlooked at the fair. In the year that gave such memorable films as *The Wizard of Oz*, *Gone with the Wind*, and *Mr. Smith Goes to Washington*, there was no mention of Hollywood and its proven ability to reach the masses. Perhaps the fair organizers saw Hollywood as too much of a competitor.

The Court of Communications stretched from the Theme Center to the Communications Building. On the side of the building was this inspirational message: "Modern means of communication span continents, bridge oceans, annihilate time and speed. Servants of freedom of thought and action, they offer to all men the wisdom of the ages to free them from tyrannies and establish cooperation among the peoples of the Earth."

A colorful mural that represented the different ways mankind has communicated over the ages greeted visitors as they entered the building. The mural was the work of Eugene Savage, and the futuristic elements and style were a departure from his better-known paintings of Hawaii and Polynesia. Among other displays inside was a 12-minute show demonstrating the various means of communications and their history.

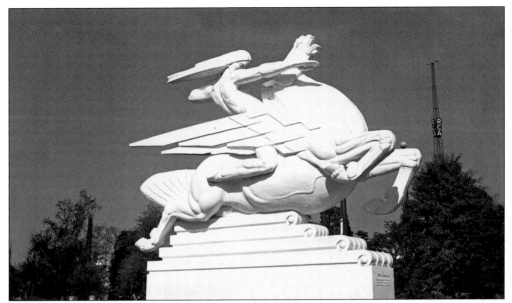

Located in front of the Communications Building at the end of a long reflecting pool was the statue *Speed*, by Joseph E. Reiner. The streamlined figures, reminiscent of Mercury and Pegasus, two well-known speedsters, were described on the base as a "Modern Equestrian Group—Symbol of the Breath-taking Speed of Today's Methods of Communications."

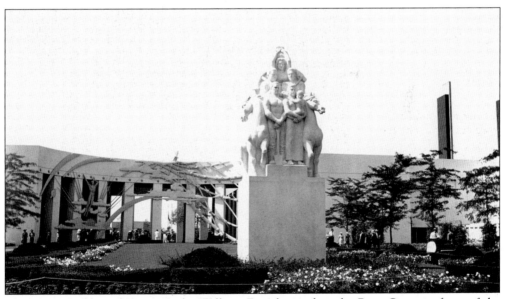

The statue *Builders of Tomorrow* by William Zorach stood in the Rose Court in front of the Business Systems and Insurance Building. The exhibits inside were unlikely to attract many repeat visitors for they consisted of displays on banking, life insurance companies, calculators, safes, and other office equipment. The most popular displays were a 14-ton typewriter, the largest in the world, and IBM's Gallery of Art and Science.

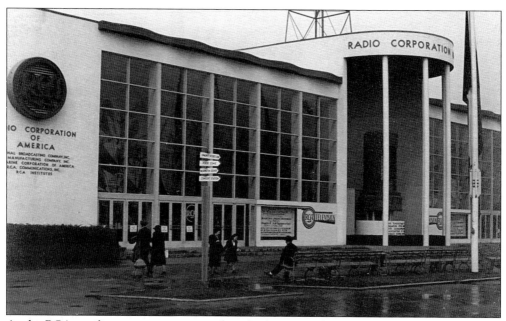

At the RCA pavilion, guests were treated to the latest wonders in communications. Contrary to popular belief, television was not debuted here, having been displayed at several earlier expositions, but there was a complete television studio and plenty of televisions on hand to start developing public interest in the new medium. Other exhibits included the first FM radio broadcasts and an early facsimile machine.

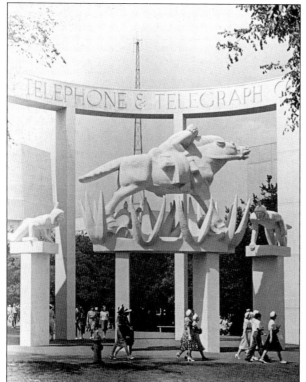

A symbol of the many changes in communications over the years, this statue group at the AT&T pavilion depicted a Pony Express rider escaping from an ambush. Exhibits inside included a history of communications and various new telephone innovations, including the Voder, a revolutionary voice synthesizer.

AT&T was one of the most popular pavilions at the fair due to its offer of a free long-distance call. Most visitors had never made such a call due to the expense involved, but the free calls came with a catch. They were not private; everyone in the auditorium heard the conversation. A giant map on the wall traced the progress as operators routed the calls.

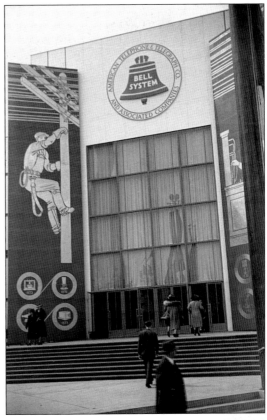

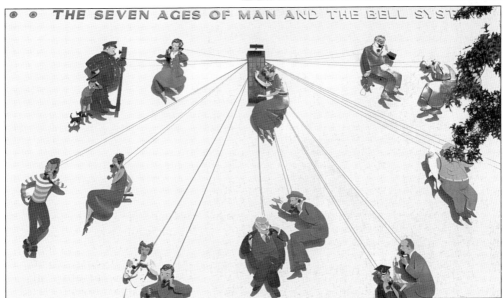

This humorous mural on the side of the AT&T building featured raised figures living their lives, which were all connected by the marvels of the telephone system. The figures included proud new parents sharing their happy news, men conducting business, families staying in touch, and in a scene that has not changed in all these years, teenagers socializing on the telephone.

A very different form of communication often attracted large crowds, such as is seen here on the street near the RCA building. Was this a demonstration of yet another new electronic marvel? Surprisingly, the popular booth was actually a concession that offered horoscopes and other astrological advice. The fair had some strange exhibits, indeed.

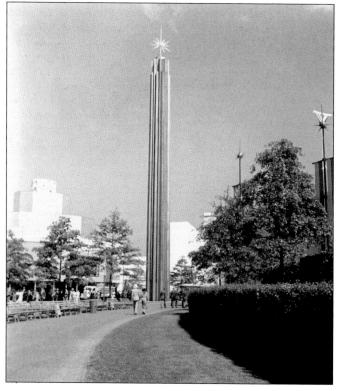

The official guidebook described the striking Star Pylon as "representing electricity's force in the world." The 130-foot-tall tower was built of varnished Douglas fir, and concealed lighting tubes provided diffused lighting. The pylon was located behind the Communications Building near the Long Island Rail Road station, and the brightly illuminated star at the top helped guide crowds back to the station on their way home at night.

Five

THE FOOD ZONE

If you pause and think, you realize that the miracle of the "loaves and fishes"
is no more incredible than the food miracles of today.
—*Official Guide Book of the New York World's Fair 1939*

Food has always been an important part of world's fairs. Heinz gave away the first of millions of pickle pins in 1893 at the World's Colombian Exposition, which is also credited with popularizing chili in the United States. The Louisiana Purchase Exposition of 1904 is known for the creation of the ice-cream cone and for popularizing iced tea, Dr. Pepper, and puffed rice cereal.

The 1939–1940 fair is not famous for any special food or drink, but the exhibits in the Food Zone were quite important nonetheless. At the time of the fair, most homemade meals were prepared daily using fresh food that came from local farms or small markets, supplemented by canned fruits and vegetables. Many foods were only available during short growing seasons or were relatively unknown. Seeing a potential vast new market before them, several of the country's largest food manufacturers used the fair to get their products into public view.

Preparing meals should be easy. That was the key message at many of the pavilions. There was no need to spend hours in the kitchen baking bread when you could pick up a loaf at the market. Frozen foods offered a wider range of ingredients, were easy to prepare, and were available year-round. Quicker shipping using refrigerated trucks and trains meant a wider selection of fresh fruits and vegetables in local markets.

While all the Food Zone exhibits had been created to drive future sales, there was also an educational component to most of the pavilions. The concept of a balanced diet was explored, along with the importance of watching calories and taking vitamins. Knowing that most visitors would have quickly brushed off such issues as dull and unimportant, these shows included circus animals, mechanical hosts, performing cows, Edgar Bergen's famous costar Charlie McCarthy, and perhaps the most successful element of all: free samples.

Not all the displays were about healthy products though. Several of the pavilions were sponsored by companies that sold tobacco or alcohol products, items generally not considered food even in the less-educated days of the fair.

The main route through the Food Zone was the Avenue of Pioneers, seen here from the corner of Market Street. At the opposite end was Lincoln Square, site of the Schaefer Center. The arrow-shaped shafts to the left were two of the four oversized stalks of wheat that marked the zone's theme building, the unimaginatively named Food Building No. 3.

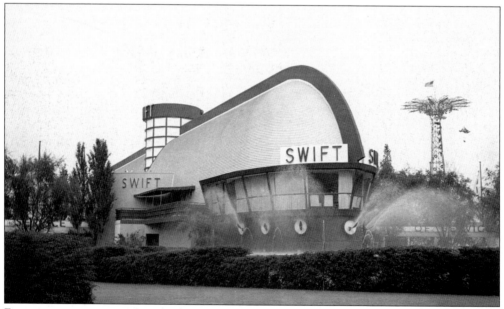

Fairgoers got to see something at the Swift and Company pavilion that was probably not seen at any other world's fair—raw meat processed into hot dogs. Guests could also watch bacon being packaged and other examples of how meat is prepared for sale. The pavilion included displays on the roles of livestock farmers, butchers, and retailers. Visitors received free recipe booklets and could eat at a café that served Swift's products.

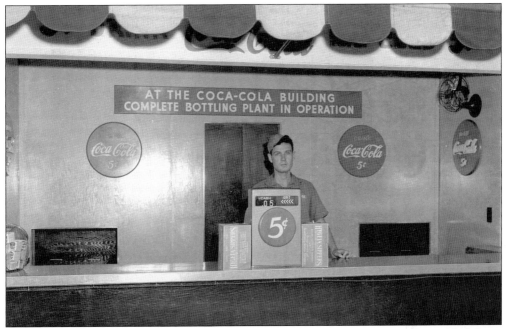

The Coca-Cola Company had a major presence at the fair. Guests could grab a cold Coke at fast-service counters like this rather spartan outlet or in many of the full-service restaurants in other pavilions. Those interested in learning more about the company and its products could also visit the Bottling Plant of the Future, which turned out 140 bottles per minute.

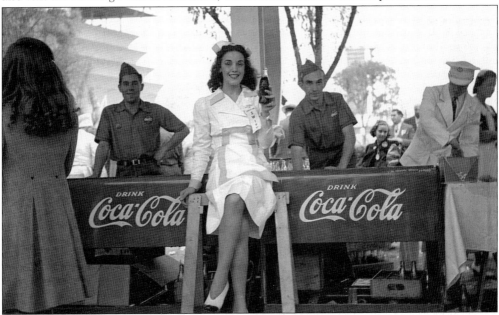

One of the Coca-Cola advertising slogans in 1939 was "Whoever you are, whatever you do, wherever you may be, when you think of refreshment, think of ice cold Coca-Cola." This hostess from the Swift pavilion helped bring that slogan to life as she posed at the pavilion's outdoor snack bar. Photo opportunities such as this were part of an advertising campaign that highlighted Coke products throughout the fairgrounds.

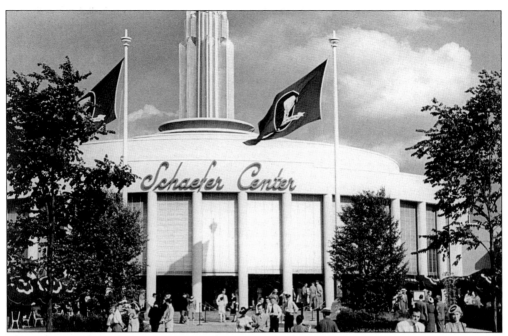

Those wanting something more potent than a soft drink could wet their whistle at the Schaefer Center. The circular pavilion featured a 120-foot-long bar, one of the largest in the world, and a 1,600-seat restaurant, which offered up several dishes using beer as an ingredient. Overhead a giant mural traced the history of beer from the days of the Phoenicians to modern brewing practices.

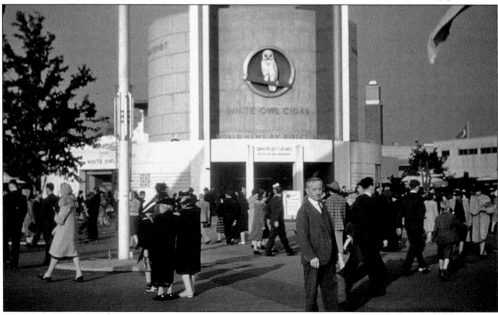

The General Cigar Corporation pavilion, also known as the White Owl Cigar building, was aimed at the men in the crowd. Displays showed how tobacco was grown, harvested, and cured and how it was transformed into cigars. The high point of the pavilion was a lounge with comfortable chairs and couches where guests could enjoy a smoke as they watched the latest sport results.

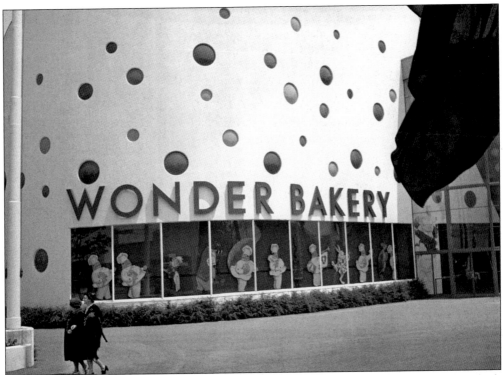

The Wonder Bakery was the focal point of the Continental Baking Company exhibit, which also featured Hostess cakes. Inside the building, which was styled after a colorful Wonder Bread wrapper, displays followed the steps to process raw flour into loaves of bread. Meals made with the bread baked in the pavilion were on sale at the Wonder Sandwich Bar.

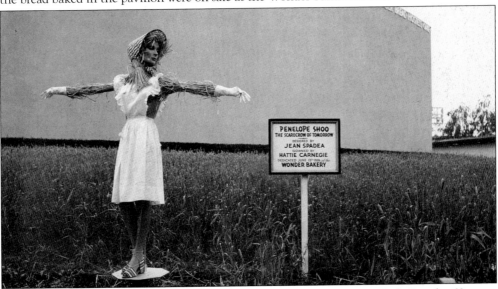

Behind the Wonder Bakery exhibit was a wheat field, the first in New York City for 68 years, complete with its own scarecrow, dubbed Penelope Shoo. The stylish mannequin was dressed in a variety of costumes designed by Jean Spadea, who was well known for her department store window displays in Manhattan, and Hattie Carnegie, a successful dress and jewelry designer.

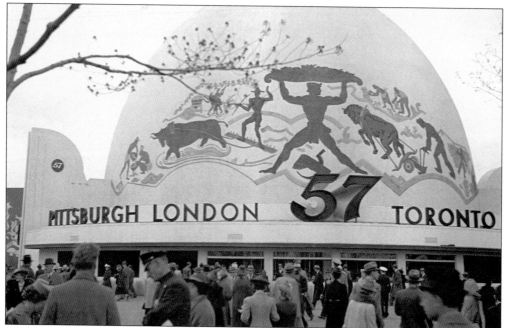

When its request for a pickle-shaped building was rejected, Heinz moved into what had been planned as the Fisheries Building. The 75-foot-high dome was decorated with the mural *Harvest—Occidental and Oriental* by Domenico Mortellito. Animated stage shows inside explained the many steps it took to create a seemingly simple product like baby food. Following the tradition started in 1893, visitors received free pickle pins to wear on their lapels.

The Beech-Nut pavilion, like many others at the fair, had displays about the history and manufacturing of the company's products. What set this one apart was a miniature circus, billed as the "Biggest Little Show on Earth," that featured acrobats, clowns, aerialists, and exotic animals. To complete the experience, there were free samples of coffee and other Beech-Nut products.

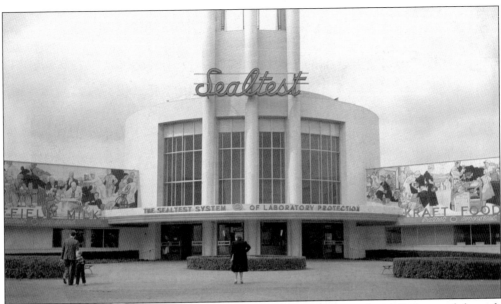

The Sealtest pavilion demonstrated the company's namesake process for quality control through examples of each step in turning milk into cheese, ice cream, and other products. Sheffield Milk's modern bottling plant could pasteurize and bottle enough milk for a city of 15,000 people. The Kraft portion of the exhibit showed the latest in automation as robotic fingers amazed crowds by packing bars of Philadelphia Cream Cheese into cartons.

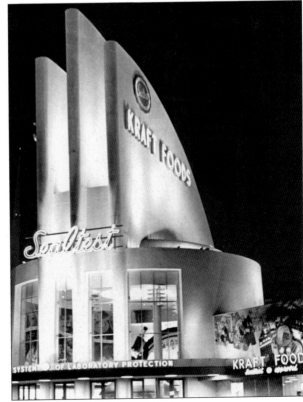

The unusual architecture of the fair made it look interesting enough during the day, but many of the pavilions looked even better when the sun went down. The fair designers made excellent use of newly invented lighting techniques to create dramatic schemes that added a completely new perspective to nighttime viewing.

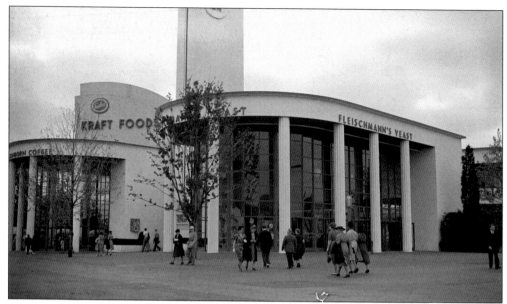

Next door to Sealtest was the Standard Brands building, which housed exhibits by Chase and Sanborn Coffee, Fleischmann's Yeast, the Baking Industry, and Royal Desserts. The Chase and Sanborn exhibit was especially popular as it starred Edgar Bergen and Charlie McCarthy. After enjoying a drink at the 125-foot Coffee and Tea Bar, guests could hop on a stationary bicycle to see how much electricity they could generate.

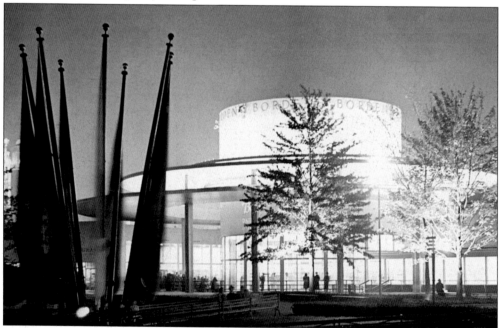

The glass walls of the Borden pavilion provided views of 150 dairy cattle being automatically washed, dried, and milked on a rotating platform called the Rotolactor. After being pasteurized and bottled, the milk was available at the Dairy World Restaurant. The pavilion was also the home of Borden's famous living trademark, Elsie the Cow, who made her public debut at the fair.

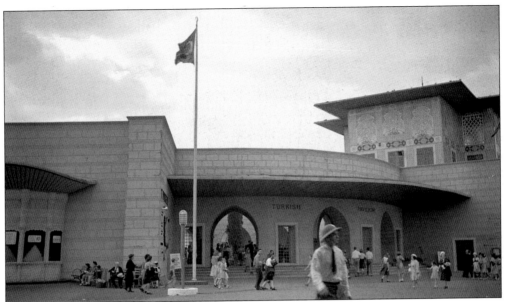

Turkey was one of two countries that somehow were located in the Food Zone instead of the more fitting Government Zone. The building recreated a Turkish bazaar with shops that offered a variety of traditional products, including tobaccos and liqueurs. Artisans demonstrated their skills in rug-crafting, copper and brass work, and leather goods.

Sweden was the other country in the Food Zone. The most popular part of this architecturally well-received pavilion was the Three Crowns restaurant, which featured a unique appetizer table. Credited with originating the word *smorgasbord*, the table entertained diners by rotating into the kitchen where empty spaces were quickly refilled with more food.

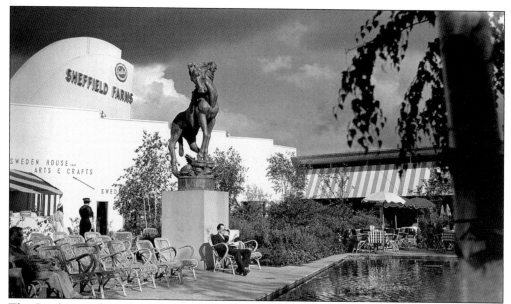

The Sweden pavilion also offered a quiet spot away from the hustle and bustle of the fair with lounge chairs and umbrella-covered tables surrounding a reflecting pool. Shops full of Swedish products ringed the area, which also featured statues by Swedish artists. Here a well-dressed visitor takes some time out from sightseeing to relax and read the newspaper.

The fair offered some of the finest meals in the New York area, especially in the foreign pavilions. Sometimes, though, the best food experience of all was an ice-cream cone. There were more than 200 snack bars and concession stands for the budget conscious, the young at heart, and those in a rush to see more of the fair.

Six

THE GOVERNMENT ZONE

*Here the peoples of the world unite in amity and understanding, impelled by a friendly rivalry
and working toward a common purpose: to set forth their achievements of today
and their contributions to the "World of Tomorrow."*
— *Official Guide Book of the New York World's Fair 1939*

Of all the themed sections of the fair, the most important by far was the Government Zone. While many of the industrial pavilions were quite impressive and drew larger crowds, they were not what made a world's fair more than just a giant trade show. As the very term *world's fair* implies, a successful exposition will have a significant level of international participation. The 1939–1940 New York World's Fair more than succeeded in this area.

One of the criticisms of Chicago's Century of Progress was that it had few international pavilions. Determined to correct this at his fair, Grover Whalen made a significant effort to get as many countries as possible signed on as exhibitors. Whalen made numerous trips overseas, including a crucial visit to the all-important Bureau International des Expositions (BIE) in Paris.

The BIE had been formed to control the number of fairs around the world to keep them from becoming too commonplace or conflicting with each other in their competition for exhibits and audiences. Whalen knew that it was essential to obtain BIE approval if he wanted its member nations to appear at the New York fair, but to do so he needed to make a significant concession.

BIE rules limit a fair to a single season, but Whalen and his team had planned a fair that was so big and so grand that it would take two years to recoup the building costs. Whalen skirted the rule by announcing that the fair would be for one season, and the BIE gave its consent.

Whalen's sales efforts paid off, and 60 nations signed up, several of them participating in their first world's fair. One noticeable exception was Germany, for despite a concerted effort, the fair was unable to strike a deal for a German pavilion. The realities of the world's political situation were already taking a toll on events such as the fair.

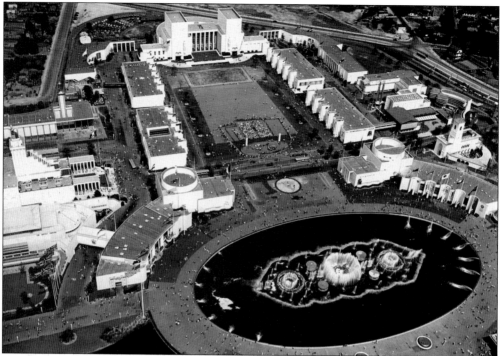

The Government Zone was one of the largest sections of the fair. Anchored by the oval-shaped Lagoon of Nations, two rows of buildings on either side of a large plaza called the Court of Peace housed the smaller international exhibits, with the Federal Building at the far end. Off to both sides of this view were the state and larger international pavilions.

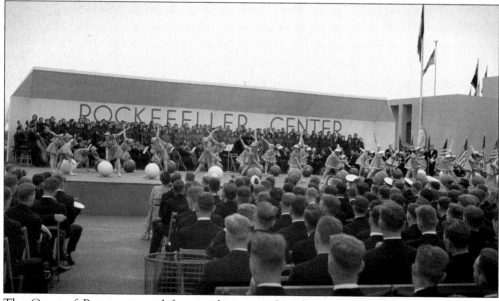

The Court of Peace was used for a wide range of performances. Special salutes were held regularly to honor the exhibiting nations, usually with performances of native dances or parades by affiliated social groups. The area was also used for other events such as this celebration of the completion of Rockefeller Center in Manhattan.

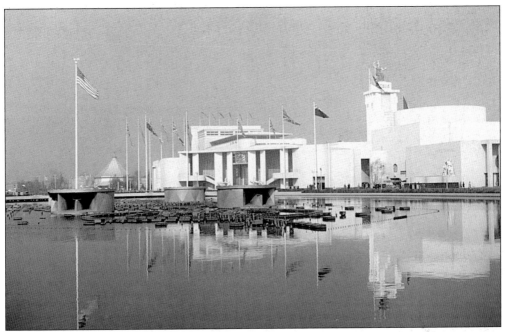

The Lagoon of Nations had been created by widening a section of the Flushing River. Because the water level changed due to tidal action, a dam was used to lower the water level to allow the servicing of the fountains and the loading of shells used in the nightly fireworks display. This view was taken just before the fountains were switched on for the day.

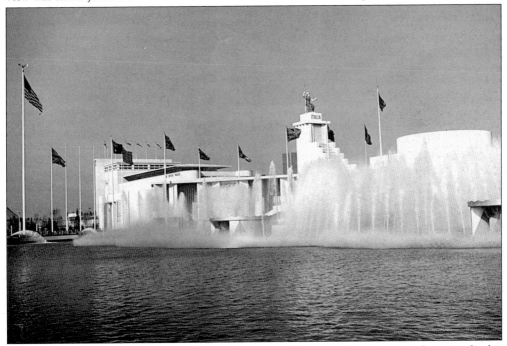

Taken just moments after the view above, this picture illustrates the impressive fountain display the crowds enjoyed as part of the sights and sounds of the Government Zone. The oval-shaped lagoon, the width of four city blocks, featured 1,400 high-pressure water nozzles set to music.

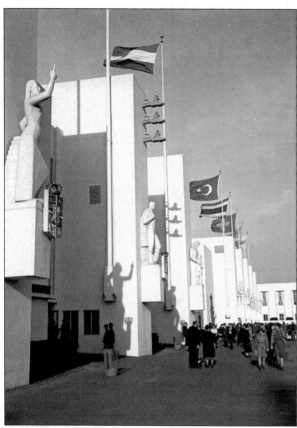

There were numerous smaller international exhibits grouped together in several buildings, which were collectively called the Hall of Nations. This section stretched along the Court of Peace toward the Federal Building, with similar groups of exhibits in other buildings located across the open plaza.

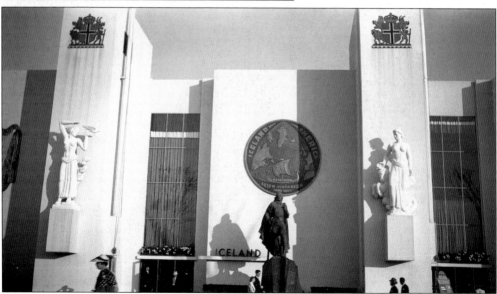

The fair is still remembered for its large number of international exhibits. Not requiring each country to build its own expensive structure made it easier for fair officials to get so many countries to participate. Countries not seen at other fairs, such as Iceland, could thus afford to showcase their national treasures and cultures.

Several countries actually had two completely different exhibits at the fair. For example, while the government of Japan had its own elaborate pavilion, this display in the Hall of Nations was backed by Japanese businesses. In some cases, the pavilions were linked by pedestrian bridges, but others were quite a distance apart.

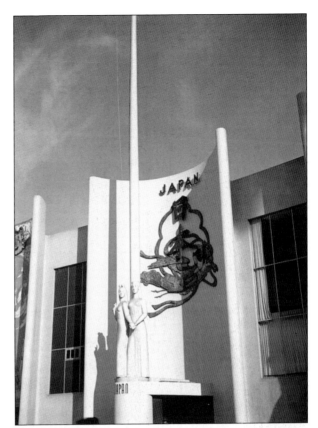

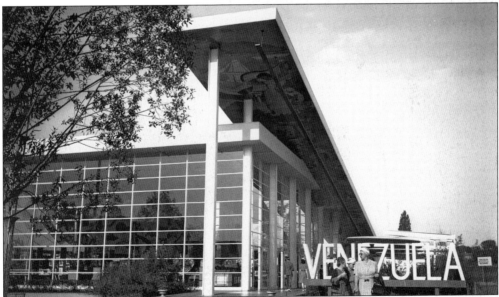

The sharp angular lines of the Venezuela pavilion were a marked contrast to the art deco style of many of the other buildings at the fair. The pavilion's primary design firm, Skidmore and Owens, was also responsible for much of the fair's master planning and design coordination, making this departure from the general motif all the more intriguing.

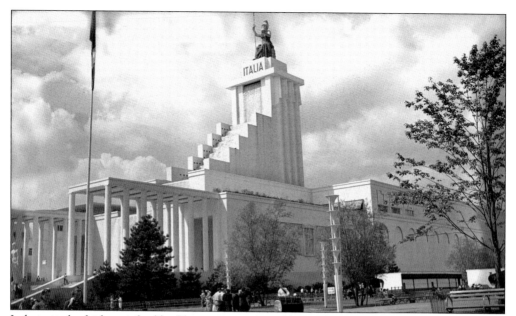

Italy turned a fairly standard building into a memorable pavilion by adding a giant statue of the goddess Roma atop a cascading waterfall, which made it one of the tallest structures at the fair. The pavilion closed in June 1940 when Italy entered World War II, and the dark and empty building was a very visible reminder of the war for the rest of the season.

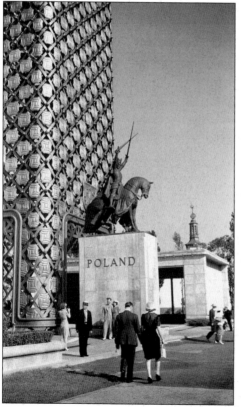

Visitors to the Poland pavilion passed by a statue of King Jagiello, who united Lithuania and Poland and became king after marrying the queen of Poland in 1386. The king is depicted holding two swords taken from his foes at the pivotal Battle of Grunewald. The statue is now located in New York's Central Park.

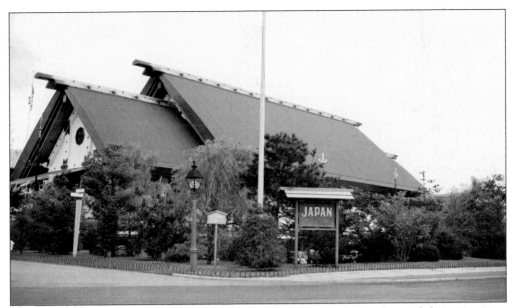

The main Japan pavilion, which resembled an ancient Shinto shrine, featured demonstrations of Japanese art and culture inside the building and in the surrounding gardens. In a sign of the wars raging overseas, the pavilion included the Formosa Tea Garden; the Chinese island, known today as Taiwan, was then under Japanese rule.

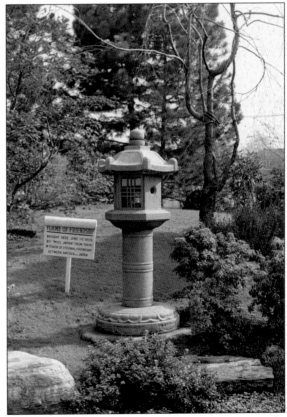

In the Japanese garden stood a simple stone lantern and a sign reading, "Flame of Friendship—Brought here June 1st, 1939 by 'Miss Japan' from Tokyo in token of eternal friendship between America and Japan." The attack on Pearl Harbor two and a half years later showed just how short eternity would last.

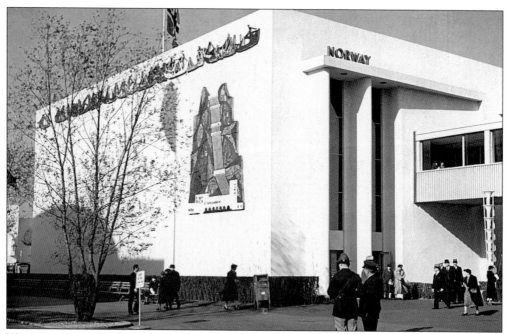

The Norway pavilion consisted of two buildings, with the modern industrial exhibits in the Hall of Nations, pictured here. A pedestrian bridge crossed to the main pavilion, which housed a theater, a restaurant with a popular outdoor patio, and displays about the country's history, famous Norsemen, and examples of Norway's scenic wonders, art, and native products.

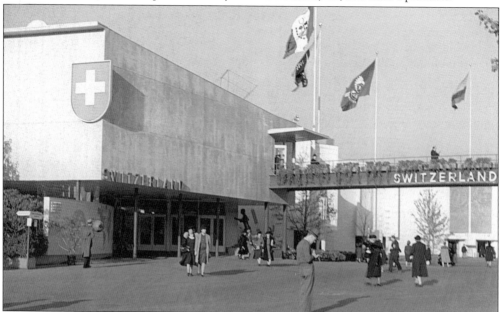

Switzerland was another country with a two-part pavilion. The exhibits included films of the famous Swiss scenery and demonstrations of yodeling, dancing, and Swiss music. Visitors could pose for a picture on a simulated mountain, learn about the manufacture of cheese, or enjoy native foods in the restaurant. Products on display included a variety of textiles and, of course, Swiss watches.

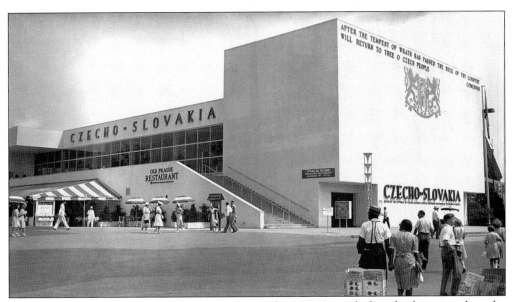

Czechoslovakia was annexed by Germany on March 13, 1939, just before the fair opened, so the pavilion's operators posted the giant slogan "After the Tempest of Wrath has Passed, the Rule of thy Country will Return to Thee, O Czech People" as a visible snub to its German occupiers. The pavilion management also rejected Germany's demands to send the pavilion's artwork and other exhibits back to Czechoslovakia.

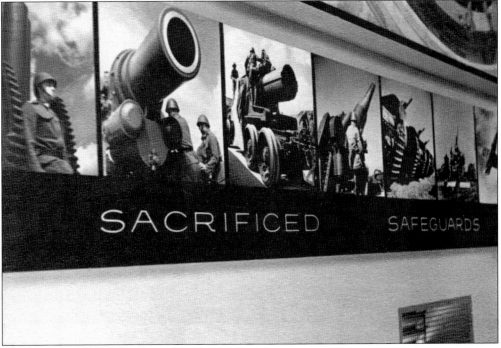

Displays inside the pavilion also promoted the antiwar message, such as this mural of Czechoslovakian soldiers preparing for war. The pavilion raised money for the exiled government in London by requesting donations and through the sale of souvenirs that included postal items with a special imprint for the fair.

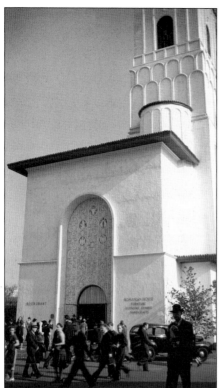

While some countries had a smaller second location in the Hall of Nations, Romania had two full-size pavilions. Pictured is Romanian House, which was styled after ancient watchtowers. It housed a restaurant and craft displays, and displays on Romanian history were located in the separate Romanian National Hall.

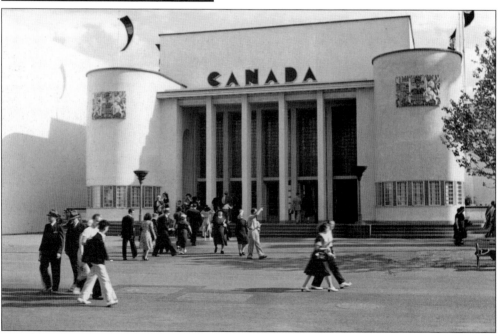

A wide variety of native materials was used to build the Canada pavilion. One of the two display halls inside focused on the country's scenery, using photomurals and dioramas of some of the better-known tourist attractions. The second hall featured some of Canada's major industries, including mining, hydropower, farming, and forestry.

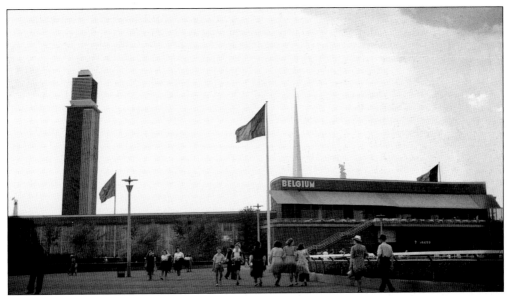

A 155-foot carillon tower drew the eye toward the Belgium pavilion, which included a 500-seat restaurant, shops, and a theater. The building is one of the few surviving fair structures, having been donated to Virginia Union University in Richmond, Virginia. The 36 carillon bells are now installed in the Hoover Tower at Stanford University.

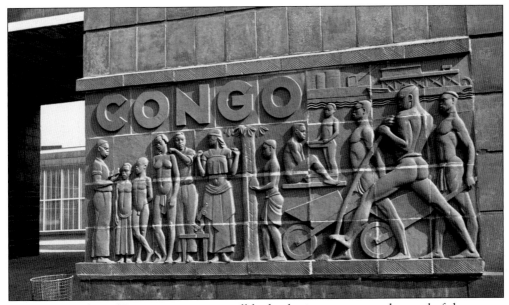

In 1939, a number of European countries still had colonies overseas, and several of those were participants at the fair. This frieze was part of the display for the Belgian Congo, a Belgian colony since 1908. Independent since 1960, it is now the independent Democratic Republic of the Congo. This frieze can be seen today at Virginia Union University.

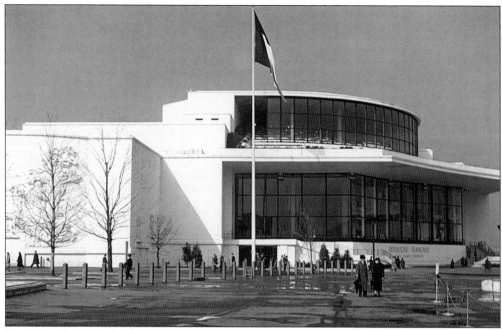

France had one of the largest pavilions in the Government Zone and a prominent location overlooking the Lagoon of Nations. The pavilion was very popular, especially with those fortunate enough to dine in its well-regarded restaurant. The pavilion is credited with introducing the French system of chefs and kitchen duties to American restaurants.

The France pavilion featured large windows that overlooked the Lagoon of Nations, making this a favorite spot for guests to enjoy the fountains and fireworks. The windows could be opened to take advantage of days with nice weather, further adding to the experience. A smaller display in the Hall of Nations focused on France's colonies around the world.

The exhibits in the Netherlands pavilion presented a look at the three parts of the country's empire: the home country in Europe, the Dutch East Indies, and the territories of Suriname and Curacao in South America. The pavilion included a garden with 65,000 tulip bulbs, which were in addition to the one million bulbs the Netherlands donated to the fair.

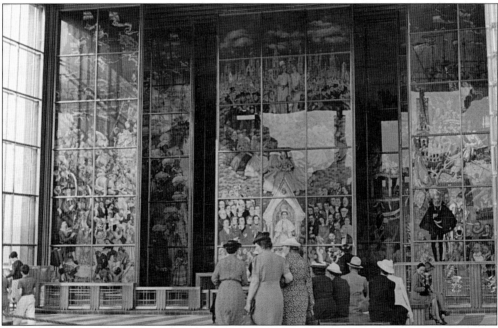

A large painting on glass at the entrance to the Netherlands pavilion had the country's monarch at its center, surrounded by elements of life in Holland and the colonies. Inside, a large animated map detailed how much of the country had been reclaimed from the sea and the challenges faced in holding back the waters.

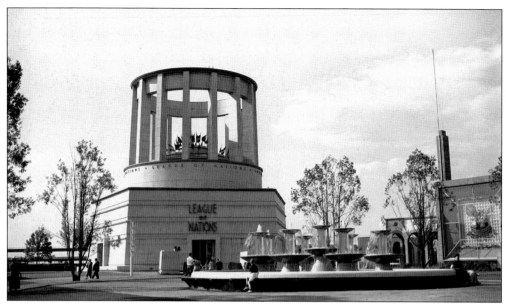

An ill-fated predecessor to the United Nations, the League of Nations was formed in 1920 with the hope it could prevent another world war and improve the quality of life for member countries. The circular turret, a symbol of unity, sat atop a pentagon-shaped base, which represented the five races of mankind. By the time of the fair, the league was increasingly seen as ineffective. It was finally disbanded in 1946.

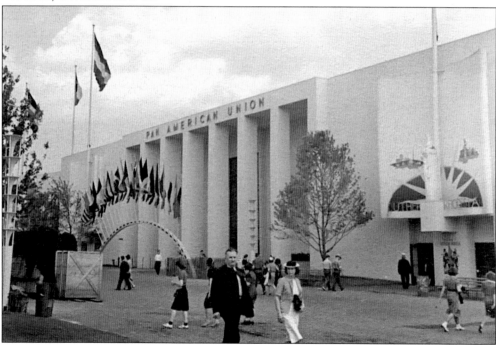

The Pan American Union was another international association at the fair. Twenty-one flags of its member nations were arranged in an arch over the pavilion entrance. Known today as the Organization of American States, the roots of the Pan American Union dated back to 1889, making it the oldest such international alliance.

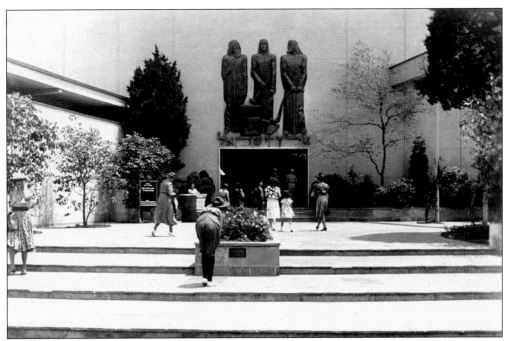

The politics of the Middle East were on display at the Jewish Palestine pavilion, which had been funded by contributions from Jewish organizations across the United States to help promote the move for a Jewish homeland. Exhibits included examples of the improvements that Jewish settlers had brought to the Holy Land, including irrigation systems, new schools, and a reduction in disease.

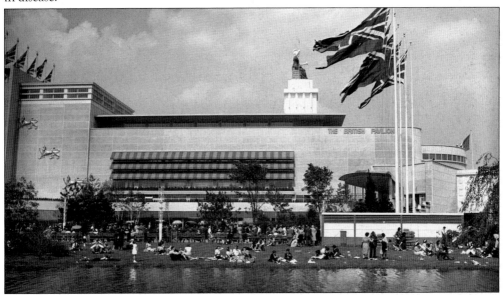

Groups of visitors relax by the water as they enjoy a beautiful day at the fair with the Great Britain pavilion as a backdrop. Great Britain, the largest of the international pavilions, exhibited a significant number of art treasures and historical artifacts, including a rare copy of the Magna Carta. Long lines formed to view replicas of the famous crown jewels, a collection of medieval weapons, and other displays about British history.

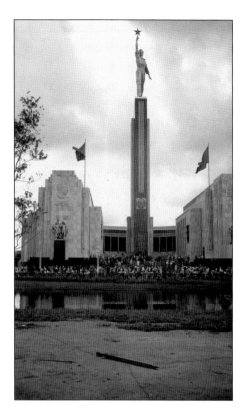

The Union of Soviet Socialist Republics (USSR) was another major participant during the 1939 season. The most visible aspect of the pavilion was a giant statue of a worker holding a red star high in the air. Dubbed "Big Joe" or "the Bronx Express Strap Hanger," the figure was second in height only to the Trylon.

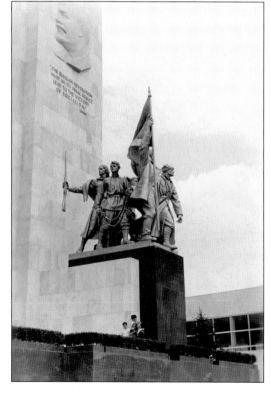

Large profiles of Vladmir Lenin and Karl Marx were on either side of the entrance, and other icons of Soviet life were distributed throughout the pavilion. These statues of a worker, soldier, sailor, woman, and young boy were in honor of those who fought in the revolution.

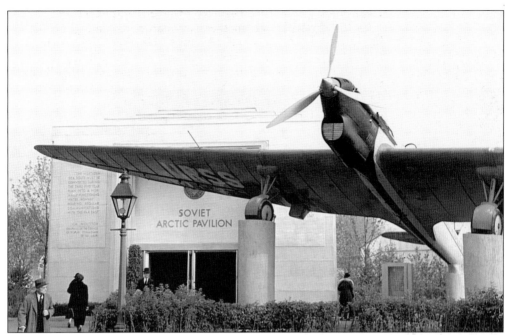

A separate building was dedicated to Soviet successes in Arctic exploration. International press coverage of major expeditions and records created a great deal of interest in polar research, and the Soviets made the most of this propaganda opportunity. Maps and dioramas highlighted Soviet bases and expeditions, and photographs depicted the explorers and their discoveries.

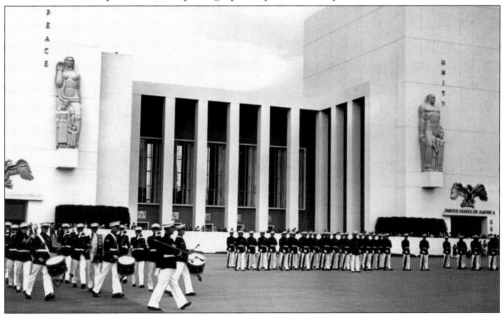

The $3 million United States Pavilion provided a dramatic backdrop for the many celebrations held at the Court of Peace. Here an honor guard of United States Marines marches in honor of Canada Day. Thirteen columns representing the original 13 states framed the center section, which housed exhibits about the executive branch. Reaching above them on either side were the Tower of Judiciary and the Tower of Legislature.

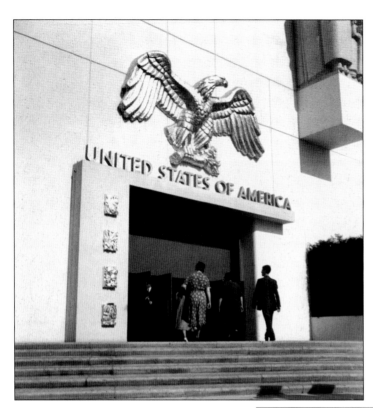

Displays of photographs, rare documents, and the film *These United States* explained the federal government's role in 12 key areas: conservation, foreign relations, finance and credit, industry, internal protection, transportation and communication, shelter, national defense, trade-education, arts and recreation, social welfare, and food. Large murals throughout the building by Eugene Savage denoted key moments in American history.

At the center of the United States Pavilion visitors could relax in a courtyard featuring statues of famous Americans, such as this one of Benjamin Franklin. The square plaques on the rear wall were copies of each state's shield or seal. Shaded benches, plants, and flowers made it a quiet oasis from the rest of the fair.

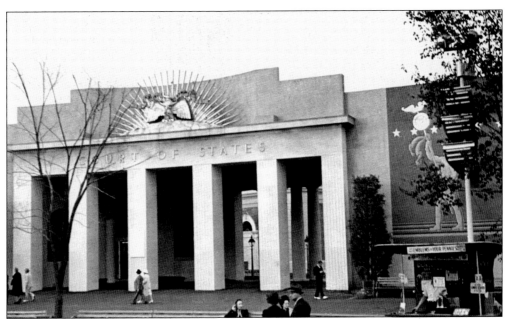

The various state exhibits were grouped together in the nine-acre Court of States, which was hidden by this rather uninspiring entrance. The fair corporation had a policy against styling pavilions after famous structures, but a waiver was granted for the Colonial architecture inside. On the right side of the picture is one of the popular elongated coin concessions that embossed fair designs onto coins.

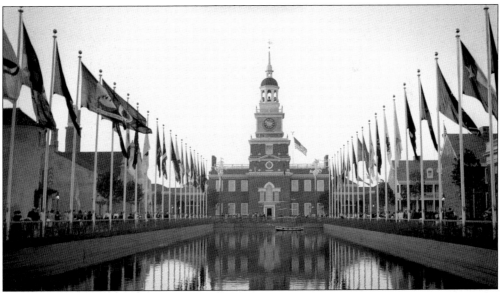

The state pavilions were set around a large rectangular reflecting pond. At the rear was the Pennsylvania pavilion, a full-sized replica of the famous Independence Hall. A replica of the Liberty Bell and a collection of historical documents were just some of the exhibits that told of Pennsylvania's history. There was also a look at the modern side of the state, with displays on industry, farming, tourism, and education.

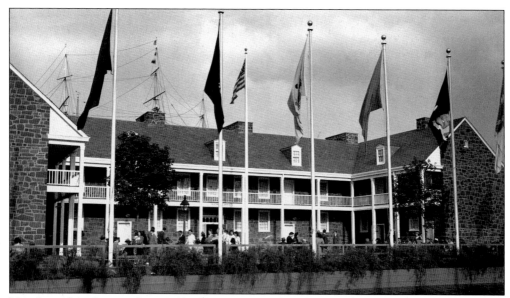

New Jersey based its pavilion on the Trenton Barracks, which had been built during the French and Indian War and captured by George Washington after his famous crossing of the Delaware River. The 15,000-square-foot pavilion hosted a variety of exhibits about the state's history and its thriving tourism industry, primarily through large photographic displays.

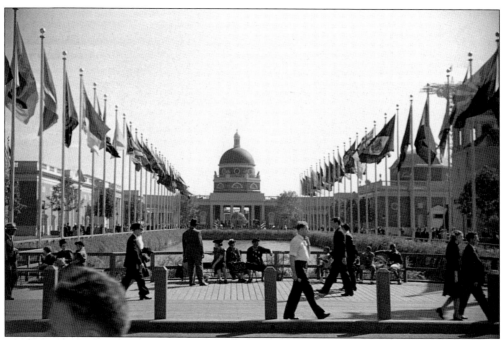

Virginia had a prominent position at the end of the Court of States in a building that also housed the exhibits of Maine, Arizona, North Carolina, and Puerto Rico. Visitors interested in learning more about Virginia could browse through albums of photographs from across the state or relax in a library containing books about the state's history.

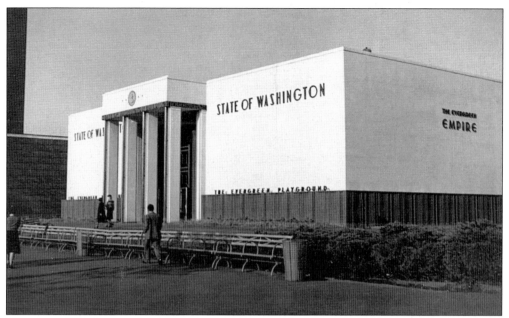

The state of Washington billed itself as "the Evergreen Empire," promoting its natural resources for industrial and tourism purposes. Dioramas highlighted the beauty of Mount Rainier, the state's vast forests, and its fishing industry. One display proudly showed the building of the Tacoma Narrows Bridge, a huge suspension bridge that became infamous when it collapsed just months after it was completed.

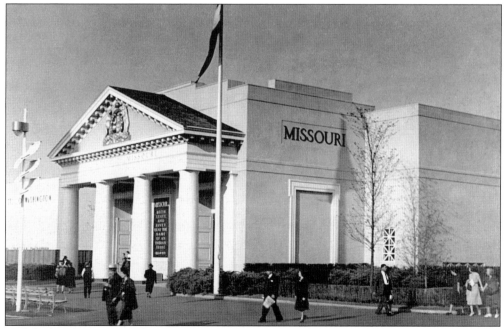

Styled after the state's Ralls County Courthouse, which was built in 1858, the Missouri pavilion, like the other state exhibits, showcased its agricultural, industrial, and scenic benefits. It also included histories of famous residents, including Thomas Hart Benton, a pioneer in transportation and communication, and writer Samuel Clemens, best known as Mark Twain.

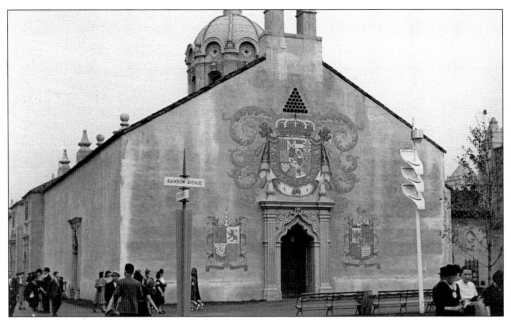

The Arkansas pavilion showcased the state's agricultural and tourism industries through photomurals, dioramas, and the film *Life in Arkansas*. Recognizing that visitors were more likely to be interested in vacations than farming, the agricultural exhibits were gradually reduced to help emphasize the state's scenic attractions. Guests could also enjoy complimentary samples of mineral water from the famous Hot Springs resort.

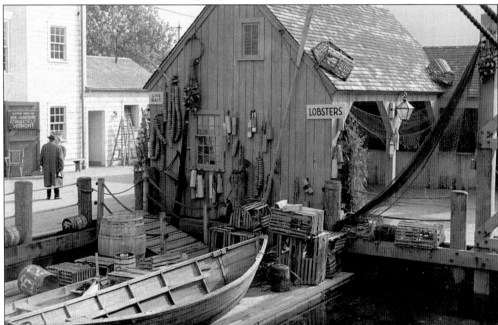

An incredible amount of detail was included in the New England exhibit, which featured displays by Connecticut, Massachusetts, Rhode Island, New Hampshire, and Vermont grouped around an artificial harbor. Surprisingly, this display of lobster boats was not from Maine, which had its own pavilion and only included indoor exhibits.

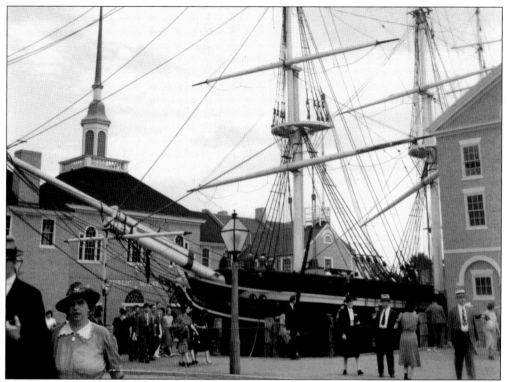

The most visible element of the New England exhibits was the Yankee, a full-size re-creation of a clipper ship that was built from vintage plans and rigged by skilled craftsmen. The landlocked vessel was popular with young visitors and photographers. Exhibits inside the ship detailed the area's rich maritime history.

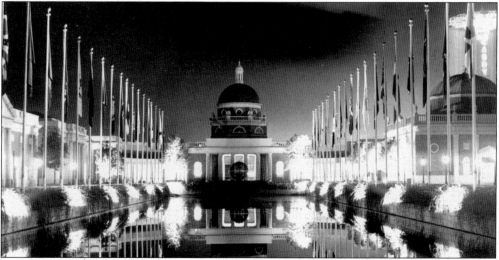

The Court of States took on a completely different look at night. The fair designers were experts in creative lighting and used concealed fixtures on both sides of the reflecting pool to brightly illuminate the area without the need for unsightly overhead lights. Fewer guests at night made the fair a photographer's dream, but the low-speed film of the time required special care to obtain shots such as this.

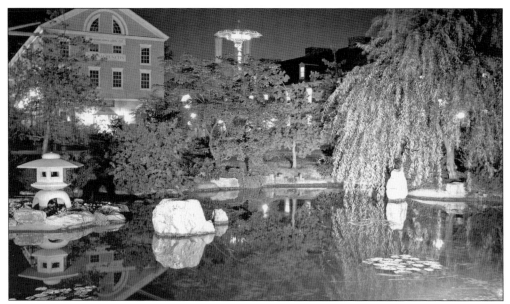

The Massachusetts pavilion and the Parachute Jump provided an interesting set of backdrops for this view of the Japanese garden. New substations and special underground cables provided the large amount of power needed to light the fair. The power system was so well designed and constructed that major portions of it were used again for the 1964–1965 New York World's Fair.

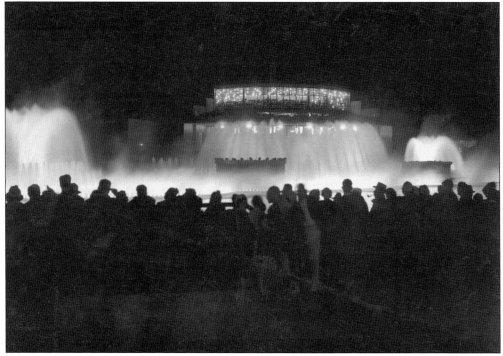

Many visitors ended their day at the fair by watching one of the two nightly fireworks shows. A traditional aerial show was held over Meadow Lake, but the best show was at the Lagoon of Nations. These fireworks were launched from within the lagoon as the fountains pulsed to music, making the event a choreographed treat for the eyes and ears.

Seven

THE COMMUNITY INTERESTS ZONE

*Visitors will understand, that in the broad sense, much of the entire Fair is devoted
to Community Interests. But here in this Zone will be found many of the exhibits which treat
more directly with Man's life in the group and his communal interests.*
—Official Guide Book of the New York World's Fair 1939

Many homes have a place to store things that do not belong anywhere else. Perhaps it is a seldom-used guest room, where old clothes and piles of books read long ago have come to rest. It might be a closet near the front door, packed full of coats, boots, and umbrellas, that is quickly walked past every day without much thought as to its contents. In many ways, the Community Interests Zone was the fair's version of such a closet.

The Community Interests Zone could have been one of the most successful at the fair, for it had two railroad stations that could handle crowds of 58,000 people per hour that emptied directly into the zone. Like the ignored closet near a front door, though, most people walked through the area on their way to see the rest of the fair.

The lack of interest is understandable. The pavilions in this section were an uninspiring lot, some with only a tenuous connection to the official themes of the zone—shelter, education, religion, recreation, and art. It is hard to understand how the exhibitors and fair corporation could have thought that people would be interested in looking at displays of radiators, asbestos, vacuum cleaners, and the ubiquitous Fuller Brush Company. There was precious little in the way of the world of tomorrow in any of the zone's pavilions.

However, there were some sections that were more successful than others. The Gardens on Parade display was popular with guests who were looking to get away from the noise of the fair. As might be expected, the Coty cosmetic counters were especially popular with women. Sadly, though, most of the exhibits were of little interest to guests, especially children. Like an entrance hallway, the zone was relegated to getting people inside but was not a place to spend much time.

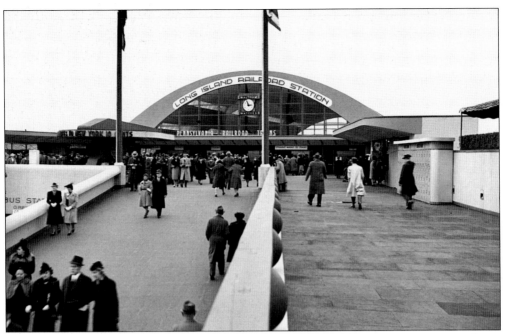

The Long Island Rail Road station was designed to handle 18,000 train passengers per hour. Special trains provided service to and from Pennsylvania Station in Manhattan every 10 minutes. There was also a Greyhound bus station on the lower level. The station was partially destroyed by a fire early during construction, and crews had to race to have it ready in time for the fair.

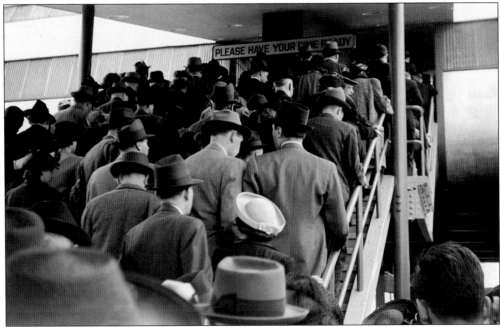

The railroad used the slogan "From the World of Today to the World of Tomorrow in ten minutes for ten cents." Most trains in the area required payment before boarding, but to speed up the loading of these trains in Manhattan, fares were collected when the passengers disembarked. The sign overhead said, "Please Have Your Dime Ready."

As soon as visitors arrived at the fair they got their first look at the dozens of statues that graced the grounds. *Industry* was one of a pair by Mahonri M. Young that was on either side of the entrance ramp leading from the station; the other was titled *Agriculture*.

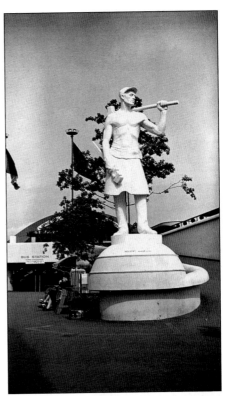

Additional rail service was provided by the city's subway lines. Riders exited the Interborough Rapid Transit/Brooklyn-Manhattan Transit station down a sprawling ramp onto the Bowling Green, a plaza at the junction of several of the fair's main thoroughfares. A third station was located in the Amusement Area on a special line constructed for the fair. Each of these subway stations could handle 40,000 passengers per hour.

This photograph from 1940 shows how empty the Community Interests Zone often was. Pictured is the Avenue of Patriots looking toward the Bowling Green plaza. In 1939, the building marked FWA on the right was the Works Progress Administration exhibit, which explained the federal government's job creation program; in 1940, it was the more generalized Federal Works Agency Building.

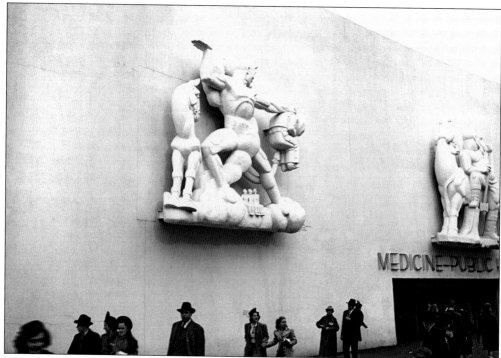

The Medicine and Public Health Building exterior featured friezes by Edmond Amateis that portrayed virtues. *Humility* showed the devil battling with folk hero Strap Buckner (at the center of the picture), *Efficiency* portrayed Paul Bunyan, and *Benevolence* featured Johnny Appleseed.

Styled to look like a powder puff box, the Maison Coty Charm Center was designed by the fair corporation to be a multiexhibitor hall for the cosmetics industry. The fair was unable to sign contracts with enough tenants, though, so Grover Whalen turned to Coty, with which he had a long-term relationship, and it agreed to sponsor the exhibit.

The main feature of the Coty pavilion was the Hall of Perfume, which demonstrated how perfume is manufactured. Other displays and a short film showcased the company's line of cosmetic products. The pavilion was designed by Donald Deskey, who had come to prominence for his designs of the Radio City Music Hall interiors.

Across the Flushing River from the rest of the zone was Gardens on Parade, a five-acre collection of gardens featuring plants, sculptures, and floral designs from around the world. Also included were installations of aquatic plants in several reflecting pools, with rotating exhibits from local floral associations.

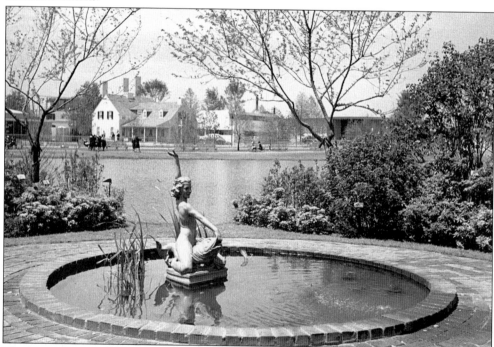

The creation of Gardens on Parade involved much more effort than simply putting plants into the ground. Detailed plans for the exhibit were prepared by William A. Delano, a prominent New York architect who had designed mansions for wealthy clients throughout the Northeast. Long interested in the gardens on those estates, he was very involved in the selection of the plants and statuary used throughout the exhibit.

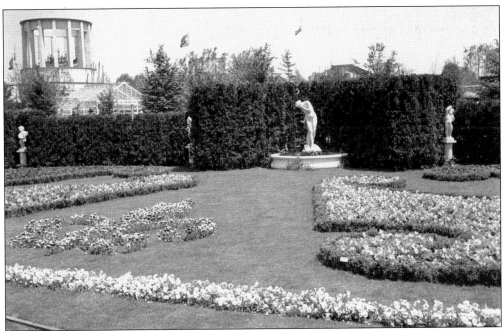

When the fair closed, the gardens became the basis for the Queens Botanical Garden, which continued to operate there until it was moved to its present site to make way for the 1964 fair. Several of the trees originally planted by Delano for the 1939 fair are now in the relocated garden, making them a little-known legacy of the fair.

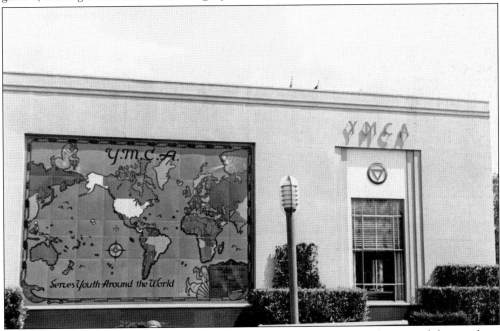

The Young Men's Christian Association (YMCA) of the City of New York operated this pavilion, which featured a mosaic tile depiction of YMCA facilities around the world. Displays inside explained the group's mission, and a quiet room provided visitors an opportunity to write to their families and friends back home.

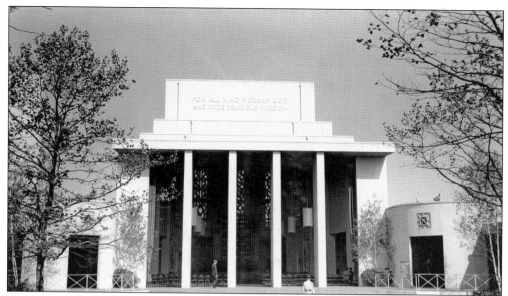

"For All Who Worship God and Prize Religious Freedom" was the theme of the Temple of Religion, a 50,000-square-foot building that included a 1,200-seat auditorium. The facility was available for use by groups of all denominations and was the site of many religious pageants, but no actual services were performed there.

The Hall of Special Events had been built as the textile building, but like the ill-fated Cosmetics Building, it too failed to attract enough tenants. When the fair opened it sat empty at first but was later offered as a rental hall to anyone who was interested. Mostly used for dancing in the evenings, the pavilion was so little known that it was not listed in some editions of the fair's official guide book.

Eight

THE PRODUCTION AND DISTRIBUTION ZONE

Stressing the increasing interdependence of peoples the world over, the Production and Distribution Zone is devoted primarily to industries whose task it is to transform natural resources into commodities necessary to the daily life of whole populations.
—Official Guide Book of the New York World's Fair 1939

If the Community Interests Zone was a disappointment, the Production and Distribution Zone more than made up for it. The list of exhibitors read like a who's who grouping of some of the most prominent American industrial concerns of the time. Each, anxious to get closer to the top of that list, spent a large amount of money trying to make their pavilion more memorable than those of the competitors.

Spending money on a large pavilion is a relatively easy task. Using that money to attract large enough crowds to recoup the investment is not as easy, especially if many of the products shown are not directly sold to consumers. The challenge faced by many of the companies was to establish a link between their products and the end goods eventually available to consumers.

For example, rather than being available for sale or even usable by an end user, most of Du Pont's products were sold to companies that then incorporated them into finished goods. Visitors to the fair were unlikely to purchase rayon fabric directly from Du Pont, but with the right sales pitch they might become interested in buying a dress or shirt made of rayon, thereby ultimately benefiting Du Pont. Even companies with a large consumer sales base had major displays on other parts of their product lines, such as Kodak's promotion of its plastics and fabrics, or General Electric's and Westinghouse's exhibits of transformers and generators.

To a large extent the companies succeeded in improving their brand recognition. Most newspaper and magazine stories about the fair included a description of Westinghouse's time capsule and robot, the man-made lightning at General Electric, or perhaps the unusual architecture employed by United States Steel. Today, even with so many companies closing or consolidating, the majority of the large exhibitors in the zone are still in business. Indeed, some are leaders in their fields.

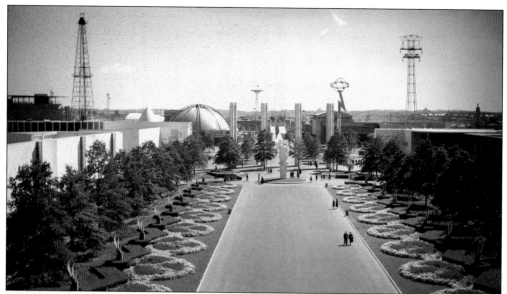

Many guests first glimpsed the Production and Distribution Zone from the Helicline. Below is the Court of Power, which led to the Plaza of Light with its circular fountain. Colorful plants masked the fact that the long walkway was actually facing the backs of the buildings on either side. More than one million tulips were used to create this beautiful display of colors and shapes.

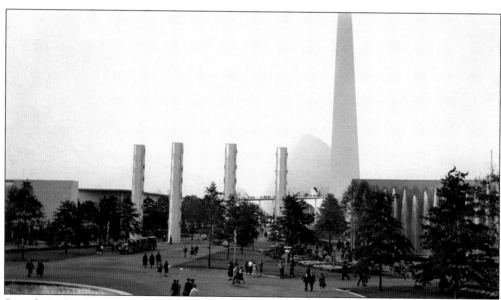

Seen from the observation trellis of the United States Steel building, the *Four Elements* by Carl Paul Jennewein were situated where the Court of Power met the Plaza of Light. A full 65 feet tall, they were, despite their stark appearance, traditional representations of earth, air, fire and water. Adorning them were 48 gold-relief plaques illustrating these elements.

The *Four Victories of Peace* sculpture by John Gregory stood at the end of the Court of Power at the entrance to the Plaza of Light. The sculpture featured oversized female figures that represented four wonders. The figures were *Wheels*, *Wings*, *Wheat*, and *Wisdom*. The large figures looked impressive even though they were standing high on a towering pedestal.

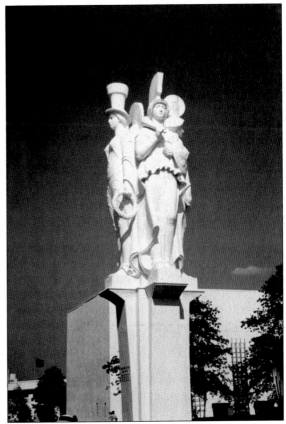

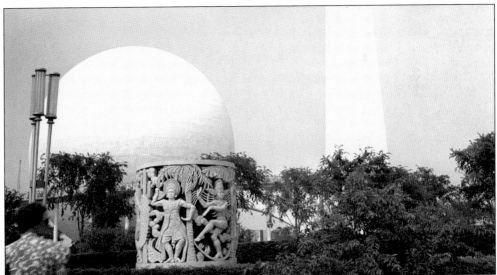

Another major artwork was *Dances of the Races* by Malvina Hoffman, which stood at the center of Perylon Circle on the edge of the zone. The circular statue, which featured oversized figures performing dances from around the world and from different years, was the central point of the Spiral Garden. A path led guests through hedges and tulips until they arrived at the statue itself.

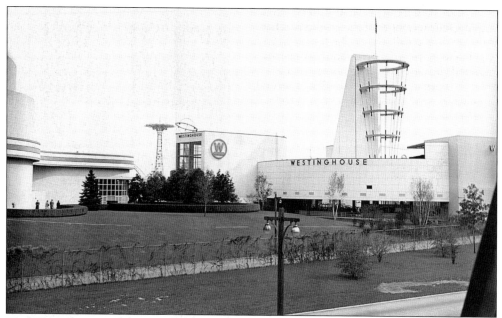

The Westinghouse exhibit was composed of the Hall of Electrical Power and the Hall of Electrical Living, which were joined at the base of the 120-foot-high Singing Tower of Light. Exhibits showed how electricity was created and transmitted, and demonstrations of new products predicted better living through electricity. The tower's rings changed color at night, alternating between red, white, and blue to the delight of motorists on the Grand Central Parkway.

No "world of tomorrow" would be complete without a robot. Elektro, the star of the Westinghouse pavilion, could respond to voice commands, walk, talk, and even smoke a cigar! In 1940, he was joined by his sidekick, Sparko the robotic dog. Elektro survived the demolition of the fair and now resides in a museum in Mansfield, Ohio.

Poor Elektro has mostly been forgotten by now, but hopefully memories of the pavilion's other major attraction will survive the test of time. Westinghouse buried a time capsule to record mankind's achievements and history that is not to be opened until the year 6939. A second capsule was buried nearby at the end of the 1964 fair.

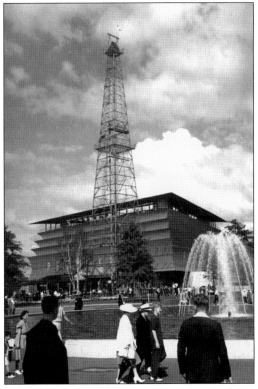

Fourteen oil companies joined to sponsor the Petroleum Industry Exhibition, which was easily located by the drilling rig towering overhead. Exhibits about the history and future of oil production included a stage show, models of drilling and pipeline systems, and an animated film starring Pete Roleum. Murals told the story of the four phases involved in getting oil to the consumer: production, transportation, research, and refining.

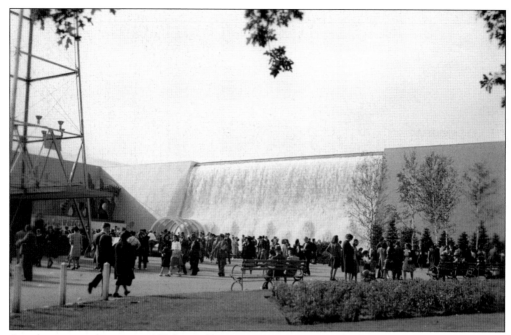

Another tower, this time a 150-foot-tall transmission tower, marked the location of the Electric Utilities Building, which faced the Plaza of Light. The pavilion's theme was the "Forward March of America," with exhibits that showed the impact electricity had on all aspects of modern life. The pavilion was sponsored by a consortium of 175 power companies from across the country.

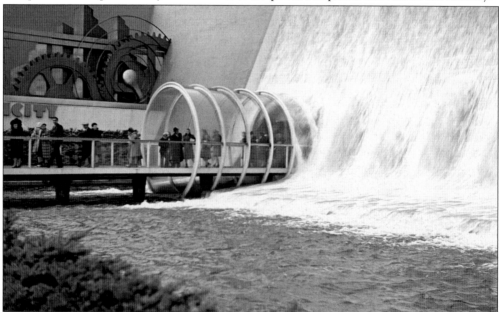

The major presentation of the Electric Utilities Building was two halls containing the same street scene: one that compared life in 1892 and the other a contemporary setting, with live actors explaining the benefits of electric power. After seeing this show and other exhibits, guests exited the pavilion through a dramatic glass-covered walkway that passed through a waterfall that covered the building's facade.

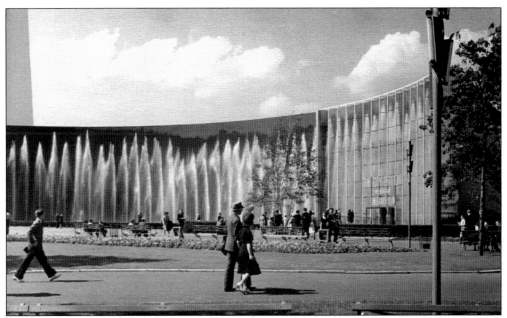

Consolidated Edison, the utility company that supplied power to much of the New York City area, had its own impressive pavilion. The focal point was the City of Light, a diorama of Manhattan that was a city block in length and more than three stories tall. Miniature trains and cars, changes in lighting, and other effects demonstrated the company's role in supplying steam, gas, and electricity.

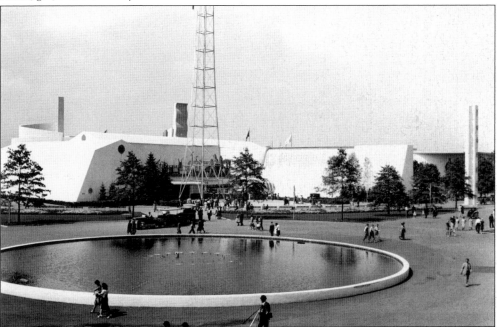

The size of the fair, amplified in this portion of the zone by low buildings and open areas, is apparent in this view from the United States Steel building looking across the Plaza of Light toward the Electrical Utilities Building. The fountain in the center of the plaza was synchronized with underwater lights and music from nearby speakers.

Eastman Kodak had a major presence at the fair with a focus on promoting color photography. The company's Kodachrome color film had been introduced in 1935 but was still viewed by many as being too expensive and too difficult to use, so much of the pavilion focused on getting photographers to try color photography, including the distribution of free film.

Guests could use their sample film in the Kodak Photo Garden, where pavilion staffers were on hand to answer questions and to provide short lessons in photography. There were several fair-themed photograph locations, such as this miniature Trylon and Perisphere. The Kodak staff would also take pictures, so even the amateur photographers could have a souvenir showing them at the fair.

Today most theme parks have automated cameras to catch images of patrons on the thrill rides for sale on the way out. The technology for this did not exist during the fair, so Kodak provided this convenient way to send the folks back home a picture ostensibly from the top of the Parachute Jump.

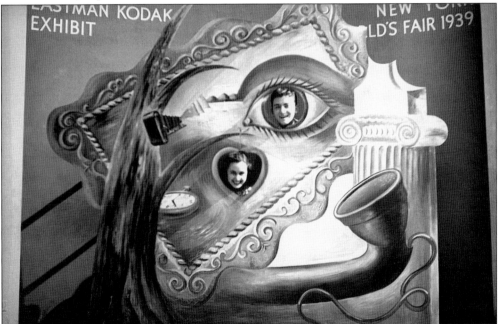

Guests could also insert themselves into this rather unusual painting in the Kodak Photo Garden that was inspired by surrealist Salvador Dali. Displays inside the pavilion showcased the work of professional and amateur photographers as well as exhibits of the Kodak product line, which included photographic chemicals, plastics, and synthetic fabrics.

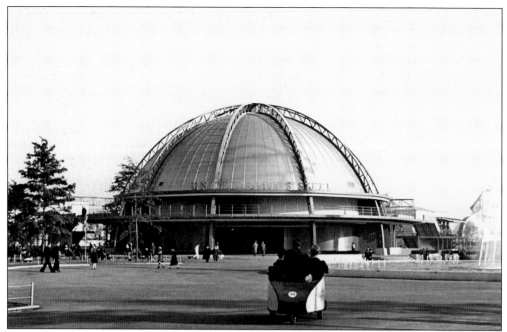

The United States Steel building was unique in that its supporting framework was on the outside of the structure. The groundbreaking design, which eliminated the need for internal supporting pillars, provided wide-open display areas within the 28,000-square-foot dome. One of the American Express motorized travel carts can be seen approaching the pavilion.

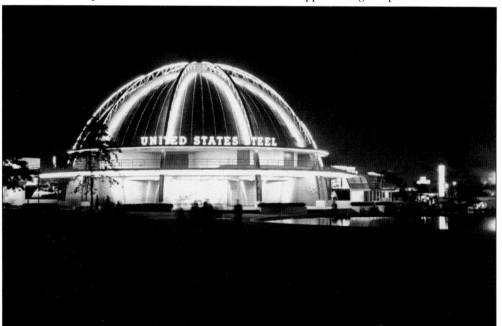

The 66-foot-high pavilion expertly matched concealed lighting with its stainless steel exterior, making it a photographic favorite at night. Exhibits inside told the story "Steel Thinks Ahead," ranging from the mining of raw ore to the creation of steel in a variety of shapes. A separate gallery told how steel would be critical in building the world of tomorrow.

In Du Pont's Hall of Chemistry, guests saw demonstrations that promoted the company's research and manufacturing operations, including the creation of rayon, one of the world's first synthetic fibers. A stage show pointed out where Du Pont products could be found in everyday objects throughout the home and office.

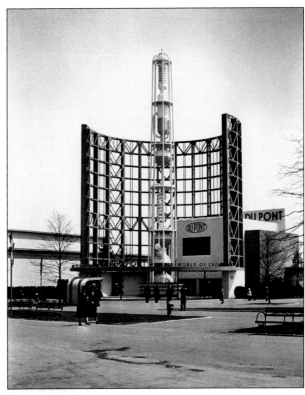

The entrance of the Wonder World of Chemistry pavilion featured a 105-foot tower comprised of a collection of oversized laboratory equipment. The giant beakers and retorts held liquids that changed colors as they swirled through the apparatus in a simulation of Du Pont's research processes. The display was especially effective when viewed at night, as the liquids seemed to glow from within.

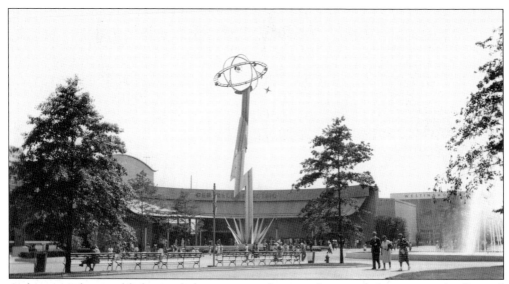

A shiny stainless steel lightning bolt set in a modernistic fountain led visitors to the General Electric pavilion. Inside, they could see demonstrations of man-made lightning in Steinmetz Hall, be entertained through electrically assisted tricks in the Hall of Magic, or tour displays of General Electric's product line in the exhibit hall.

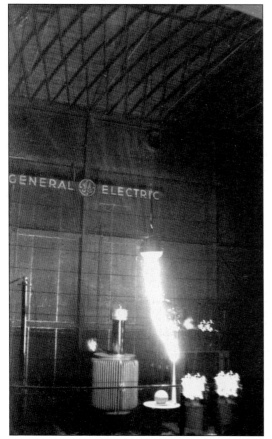

Actual laboratory equipment used to test the effects of real lightning on power lines, airplanes, and other items was re-created at the fair, unleashing colorful arcs at first and culminating in a blinding, thunderous 10 million–volt bolt striking a model of the Trylon and Perisphere in front of the thrilled (and sometimes scared) crowds.

The Glass Center was sponsored by Corning Glass Works, Owens-Illinois Glass Company, and Pittsburgh Plate Glass Company, the country's three leading glass manufacturers. While many of the fair structures were built with as few windows as possible to maximize the interior exhibit space, the Glass Center naturally showcased its namesake product with plenty of plate glass windows. The 108-foot-high tower was constructed primarily of glass blocks.

Crowds packed the Glass Center to see demonstrations that included glassblowing and the manufacture of fiberglass. The full-size glass furnace pictured here was the backdrop to a stage show that explained how glass was created and then shaped into many different forms. The mural to the left gave examples of how the versatile material could be found in many objects used in everyday life.

Surprisingly, the Glass Center was the home of the Electric Motor of Tomorrow, seen here undergoing cleaning. The motor used glass as an insulating element rather than cloth or other flammable materials that were used in conventional motors. This allowed it to run at higher temperatures, but there must have been flaws in the design because it was never placed into wide-scale use.

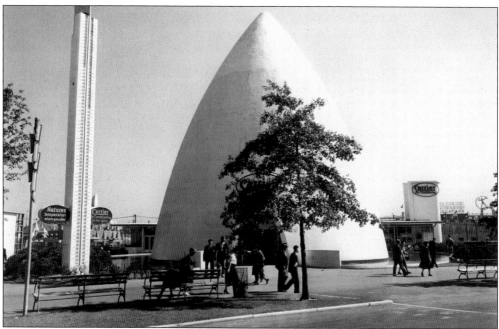

Air-conditioning was still a relatively new invention in 1939, but on hot and muggy New York days the Carrier pavilion was crowded with people wanting to learn more about it, or perhaps just to cool off for a few minutes. Two giant thermometers outside the igloo-shaped building contrasted "Nature's temperature where you stand" with "Carrier inside the igloo."

Nine

THE AMUSEMENT AREA

In many respects it is the most comprehensive collection of thrilling, laughable,
and picturesque diversions ever assembled from the far-flung corners of
the earth for the enjoyment of the peoples of the world.
—*Official Guide Book of the New York World's Fair 1939*

While much of the fair had scientific or industrial displays that promoted lofty ideals or technological advances, the Amusement Area offered up an astonishing pastiche of exhibits. There were trained animal acts near a show straight from Broadway. Guests could walk out of an extravagant water ballet and into a sideshow of nature's freaks. Some of the exhibits almost defy description, such as the pavilions that showed off live babies in incubators or nude women prancing through a re-created nudist colony. It must have seemed to visitors that all the circus sideshows had come to town.

Site surveys had shown that this part of the fairgrounds had the softest soil on the site, making it difficult to build the large pavilions seen at the rest of the fair. The engineers solved that problem by diverting the Flushing River to create Fountain Lake, with the Amusement Area curving along its shores. For the second year of the fair the lake was renamed Liberty Lake; today it is known as Meadow Lake.

Many of the exhibits in the Amusement Area were failures, and some did not stay in business through the duration of the fair. Trying to trace the comings and goings of the exhibits is difficult because some vanished so quickly that even the official guidebook could not keep up with the changes between printings. Some of the exhibits seen in vintage photographs were not listed in any editions, so there was sometimes little more than the information on their marquee to describe them.

The Amusement Area did have some successes, though. The Parachute Jump that stands over Coney Island today was the fair's most popular thrill ride, and the Aquacade set a standard for water-themed shows that has stood the test of time. Despite these bright spots, the Amusement Area is generally regarded as the least successful section of the fair. Perhaps people expect something classier at a world's fair.

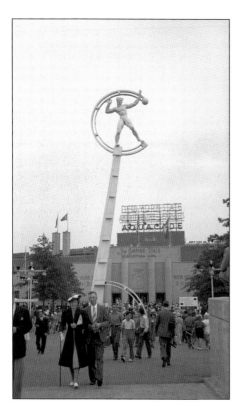

Guests entering the Amusement Area from the main portion of the fair traveled over the Empire State Bridge to the New York State Plaza, which in turn fronted the New York State Amphitheatre and Exhibits. This statue by Raoul Josset was titled *Excelsior*, the state's motto. It was unlikely that anyone could forget whose fair this was.

Another major piece of art in the Amusement Area was *The Spirit of Flight* by Gertrude Vanderbilt Whitney. A member of the famous Vanderbilt family, Whitney was a noted artist, socialite, and founder of the Whitney Museum of American Art. This was her last commissioned sculpture. It was supposed to have been moved to nearby LaGuardia Airport, but its actual location is unknown.

The major attraction in the Amusement Area, and the most successful, was Billy Rose's Aquacade. Set inside the New York State Amphitheater, the show featured 350 performers entertaining in and around a 300-foot-long pool. The show starred Johnny Weismuller (replaced in 1940 by Buster Crabbe) and Olympic backstroke champion Eleanor Holm, along with Gertrude Ederle, the first woman to swim the English Channel.

The Aquacade was often filled to capacity, and *Time* magazine estimated that one out of every six people who came to the fair also went to the Aquacade. Rose made an estimated $80,000 profit per week on the venture, a phenomenal amount of money in 1939. Rose also benefited from his sponsorship of the show in another way—he married female lead Eleanor Holm.

The crowds also lined up for Frank Buck's Jungleland. Buck had become famous for collecting animals from around the world for zoos and circuses, and this attraction featured some of the animals and the Malayan workers who worked on his expeditions. Guests could ride on elephants and camels, watch trained seals, or, for something different, see the Malayans in a re-created native village.

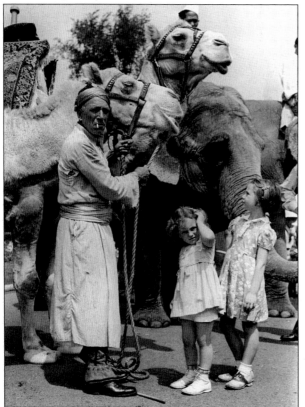

Many of the workers in the Amusement Area were straight out of the carnival or circus trade, and some were decidedly on the rough side. This camel herder would certainly never be able to get a job in today's Disney-inspired antiseptic theme parks. It is hard to tell if the young girls pictured here were more intimidated by him or by the camels.

The Parachute Jump, an iconic image of the fair, was another of the more popular attractions in the Amusement Area. Based on military parachute training towers, the ride lifted the adventurous 250 feet into the air and provided breathtaking views for those brave enough to open their eyes. One can enjoy the thrill of this ride on a near duplicate at Six Flags in New Jersey.

The riders were strapped into canvas seats, and instructions were given to pull the ripcord after the one-minute ride to the top. Many guests believed they had become stuck there, though, for the ripcord was nonfunctional and the drop was controlled from the ground after a brief but memorable delay. The ride cost 40¢, but there was always a long line of would-be adventurers ready for the experience.

Like earlier American world's fairs, this one had a midway of carnival-type games and shows. Perhaps trying to imply a better class of attractions, the fair corporation went out of its way to note that this section was called the Loop, not the midway. However, except for its name, this part of the fair was what would be expected at a cheap carnival or the seedier parts of Coney Island.

While other parts of the fair had predictions for the future or showcased the might of American industry, in the Amusement Area guests found attractions such as Frozen Alive. A rather sparse crowd of young men is pictured watching as the female staff tries to get them to come inside and see a woman frozen alive in a block of ice—for a fee, of course.

Guests looking to demonstrate their athletic prowess could do so at De-Bunk Her, which challenged them to knock a reposing beauty off her bed. While some of these sideshow attractions may have been popular, others were apparently so uninteresting or poorly presented that they did not last through the two years of the fair.

Sun Valley was one of the largest attractions in the Amusement Area. Billed as a "winter wonderland," it featured several rides and shows with Alpine themes. The thrills included a toboggan ride on a man-made mountain years before Disneyland's famous Matterhorn ride. Live shows included ice-skating, yodelers, and, most unique of all, snow falling every evening, even in the heat of a New York summer.

A 50-foot-high figure stood guard over the Giant's Causeway, which was styled after a famous natural rock formation in Ireland. In 1940, the display was rethemed to include a museum featuring "Sensational! Realistic! Startling! True! World War Photographs." Visitors had to pass by a sandbagged machine gun nest at the entrance, which was topped by a wrecked airplane.

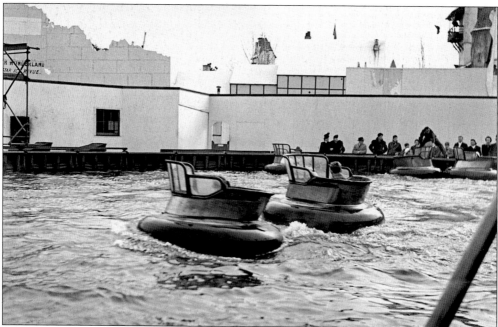

The Water Bugs ride combined the fun of traditional bumper cars with the possibility of getting wet. Twenty of the motorized circular boats were available for rent with the promise that they could not be tipped or sunk, either accidentally or on purpose. Man-made waves on the artificial lake put that theory to the test to the thrill of the riders and spectators.

The state of Florida was located on the shore of Fountain Lake, far away from the other state exhibits in the Government Zone. The pavilion was constructed of building materials from Florida and surrounded by more than 6,000 native plants. In the center patio area, guests could enjoy a glass of orange juice or eat a fresh grapefruit.

People passing the Florida pavilion were probably startled when this life-size statue of explorer Ponce de Leon started talking and invited them inside. The largest of the state displays, the pavilion promoted tourism in the Sunshine State and gave many New Yorkers their first look at a real palm tree.

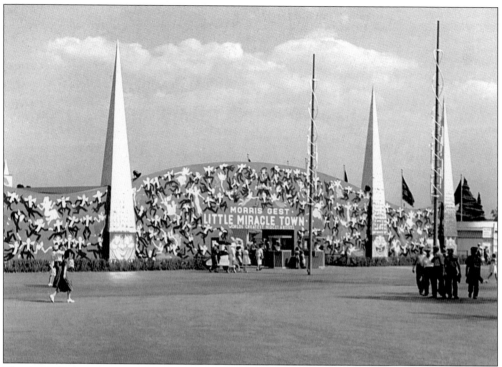

The days of political correctness were far in the future at the time of the fair. Today it is inconceivable that there could be exhibits like Morris Gest's Little Miracle Town, which featured a cast of 125 little people residents. Visitors paid 25¢ to watch the diminutive performers in scaled down buildings that included shops, restaurants, a theater, city hall, and even a railroad station.

Billed as the "Most Beautiful Presentation on the Midway," the Chinese Lama Temple was a replica of the Potala of Jehol, an actual Chinese temple with a Tibetan design. The building had first been shown at the Century of Progress in Chicago. At the end of that fair it was disassembled and stored for several years before it was shipped to New York.

The Giant Safety Rollercoaster, also billed as the Cyclone Coaster, was described as "bigger, faster, steeper, more thrilling than any ride at any previous fair." The classic wooden coaster, which was 3,000 feet long and 70 feet high, reached a top speed of 70 miles per hour. The ride in the foreground was the Centipede, a classic carnival ride much like those in modern amusement parks.

Heineken's on the Zuider Zee brought a slice of Holland to New York, complete with the requisite windmill. The complex boasted four restaurants and a bar where one could enjoy a cold glass of beer—Heinekens, of course. There were also live musicians and shops that offered Dutch crafts and other merchandise.

Ballantine's Three Ring Restaurant, named after the beer company's famous three-ring logo, was especially popular in the evenings, for it provided an excellent spot to watch the fireworks on the nearby lake while enjoying a drink. Ballantine was the country's fourth-largest brewery, but the business eventually failed, and the Ballantine beer sold today is a different formulation than that sold at the fair.

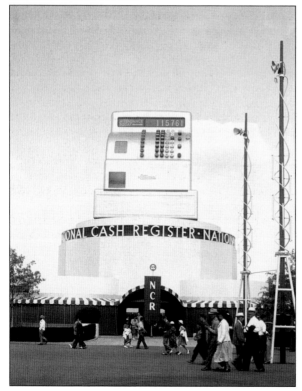

Set atop the National Cash Register pavilion, the world's largest cash register was an eye-catching attraction with a practical purpose. Linked to the turnstiles at the fair's entrances, the register displayed the daily attendance count. The company had a similar exhibit at the Golden Gate International Exposition in San Francisco.

Ten

THE 1940 SEASON

Grover is president of the Fair just the same as ever. I have just come in to help him with some details which perhaps I am better at than he is.

—Harvey Dow Gibson

Throughout the fair's first year there was a great deal of uncertainty about whether it would return for a second season. The fair had been built based on a planned attendance of 40 million for the year, but when the gates closed the attendance had topped out at only 25,817,265. In addition to the estimated $23 million lost by the fair corporation itself, many of the exhibitors and concessionaires had been unable to recoup their investments due to the resultant lower guest revenue. While a number of participants decided to cut their losses, many of the exhibitors returned for a second year in the hope of finally making a profit.

The fair of 1940 would prove to be different than the 1939 version. Harvey Dow Gibson, who had led the fair's financial committee, was elected chairman of the board. In taking over the reins from Grover Whalen, Gibson dropped many of the original plans and implemented what many critics called a "dumbed down" county fair style. The themed zones were eliminated, and buildings were leased to anyone who had a checkbook, with no consideration as to their location and design. Some pavilions were simply left empty for the second season and stood as sad reminders of the initial hopes for the fair.

The new fair also reflected the gathering winds of war, as in the new theme of "For Peace and Freedom." Fountain Lake was renamed Liberty Lake, and the massive Soviet Pavilion was shipped home and replaced by the American Common, site of a variety of patriotic and cultural displays.

However, Gibson fared no better than Whalen had. In fact, attendance was less in the second season with only 17 million guests. Although the fair was never able to repay its investors, to many it still remains the ultimate in world's fairs.

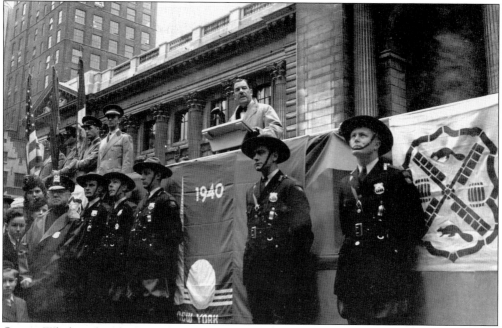

Grover Whalen played a key role in getting the fair reopened in 1940, traveling to meet with many of the exhibitors to negotiate their return. After several months of uncertainty during which many predicted he would fail, Whalen held a press conference in front of the New York City Public Library and proudly announced that the fair would indeed be back.

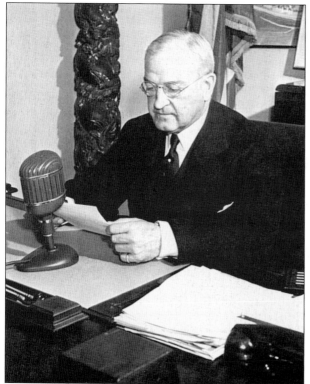

Whalen remained the public face of the fair corporation, but the second season was run by Harvey Dow Gibson, who, as head of the fair's financial committee, had approved many of the decisions later blamed on Whalen. Gibson remains a controversial figure for his stewardship of the fair.

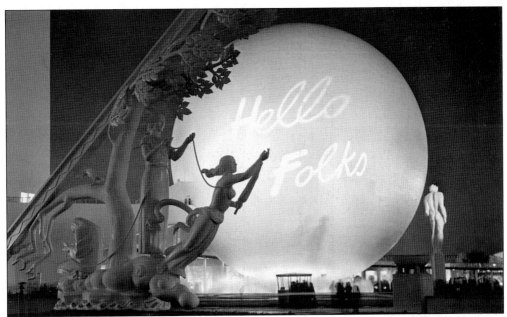

Gibson had promised the revamped fair would offer "a welcome as sincere and friendly as that of the old-fashioned county fair." This new emphasis was seen in many ways, including a completely rewritten guidebook that downplayed Whalen's lofty goals for the first year. The change in direction also included this somewhat folksy greeting displayed on the Perisphere on opening day in 1940.

Between the seasons, the marketing staff worked hard to remind people to keep the fair in their 1940 vacation plans. Publicity photographs, such as this view of the snow-covered Electric Utilities Building, were sent to newspapers around the world, along with stories that told readers there would be plenty of new and improved sights worth coming back for.

When the fair reopened, even those who were very familiar with it in 1939 needed a map to find their way around. Those first trips in 1940 were undoubtedly confusing, for the dropping of the zone concept and new names on some of the pavilions made it hard to know exactly what was where.

In some cases, exhibits from 1939 were completely replaced by new ones. One example of a wholesale change was turning 1939's Consumers Building into 1940's World of Fashion. Another notable change was the closure of the Maritime Transportation Building; when a number of its exhibitors decided not to return, the remaining ones were relocated to the Communications Building. Such was the jumble that was the 1940 fair.

Some of the changes between seasons were less elaborate, such as the simple repainting of this backdrop in the Kodak Photo Garden. While the later 1964–1965 New York World's Fair was always planned as a two-year event, the addition of a second season in 1940 kept sign painters, costumers, and souvenir vendors quite busy.

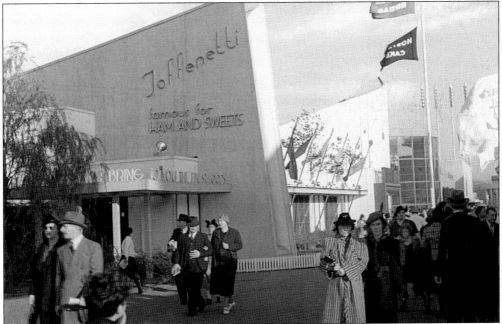

Added during the 1939 season on the site of the failed Triangle Restaurant, Toffenetti's was a small restaurant chain that started in Chicago. Following its success at the Century of Progress exposition in 1933–1934, the company expanded to New York City, billing its Times Square outlet as the "Cathedral of All Restaurants."

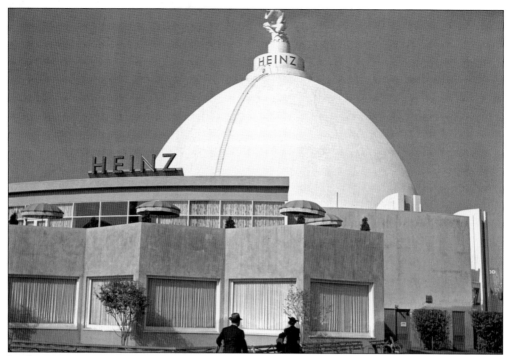

Looking to increase its visibility, Heinz moved the 16-foot-high statue of the goddess of perfection from its prior location inside the pavilion to a lofty perch on top of the dome. Exhibits inside included period kitchens from around the world, samples of Heinz products, and, for some reason, a collection of fun house mirrors.

The Danish Colony Garden was a new addition for 1940. Sponsored by the Danish-American Women's Association, it was representative of small cottages leased by the Danish government and industries to workers during the summer. The association hoped it would serve as a model for American leaders as well as a relief to urban crowding.

The Ford pavilion saw several changes for the second season. As could be expected, the company's newest cars were put into service on the Road of Tomorrow. The building itself was remodeled, including a new 40-foot-high glass facade at the entrance. The sculpture of Mercury was moved closer to street level, and a 420-seat theater was added to increase the pavilion's guest capacity.

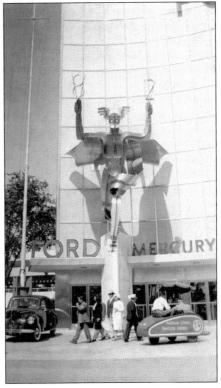

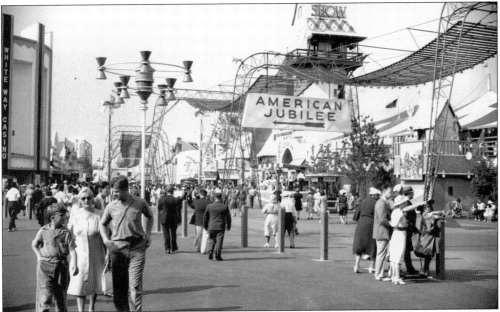

The former Amusement Area was renamed the Great White Way. That name was well known as a nickname for Broadway, but it had also been used for the midway at the World's Columbian Exposition of 1893. If some of the 1939 exhibits had seemed tacky, they paled in comparison to a number of the 1940 additions, such as the Crimson Tower, which was described as "an elaborate exhibit of medieval torture equipment."

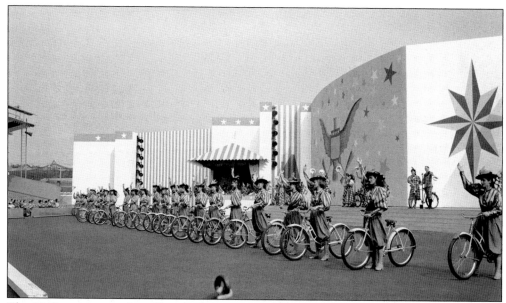

The 1940 season saw the addition of *American Jubilee,* an elaborate stage show that featured more than 300 performers and 40 trained horses that re-created pivotal moments in American history on a 300-foot-long outdoor stage. The show was a popular addition and attracted large crowds throughout the season.

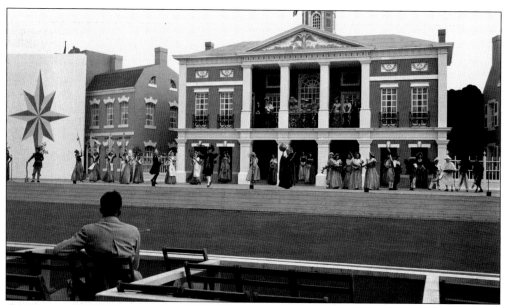

The show was the creative work of Arthur Schwartz (music), Oscar Hammerstein II (book and lyrics), Leon Leonidoff (director), and Albert Johnson (producer). For 40¢ guests saw George Washington's inauguration, the discovery of gold in California, Abraham Lincoln's Gettysburg Address and arrival at Ford's Theatre, Jenny Lind singing, Lillian Russell and "Diamond Jim" Brady celebrating the Gay Nineties, and other scenes in elaborate stage sets.

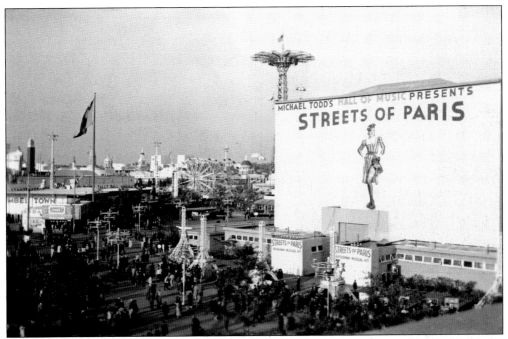

In 1939, the World's Fair Music Hall was the site of the critically acclaimed *Hot Mikado* starring Bill "Bojangles" Robinson. In keeping with the more sensational theme of the second season the show that year was *Streets of Paris*, which starred Gypsy Rose Lee with Bud Abbott and Lou Costello. Both shows were produced by Michael Todd, who went on to become a successful Broadway and Hollywood producer.

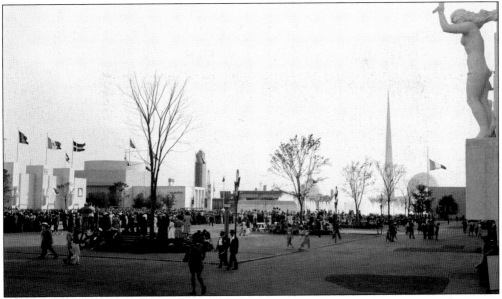

Several of the countries that had been at the fair in 1939 had since been overrun by enemy armies, forcing some of them to close or turn the operation over to American-based supporters. Some pavilions were draped in black bunting, while others such as Poland and France flew their flags at half-mast, as seen on the right side of this view of the Court of Peace.

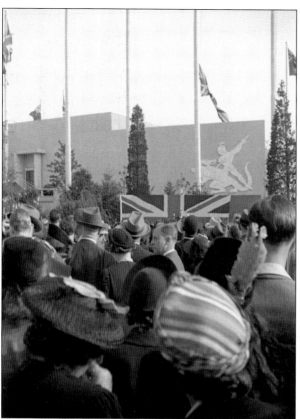

Many of the exhibiting countries used the fair as a venue to draw attention to their plight and to solicit donations from countrymen in the United States. For example, the Great Britain pavilion added a display on the war with Germany that included wreckage of a downed Luftwaffe plane, as well as platforms outside the pavilion for political rallies that drew large crowds.

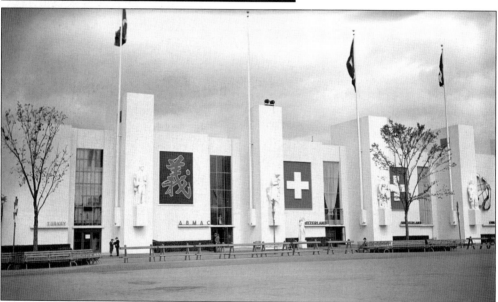

The ABMAC pavilion was operated by the American Bureau for Medical Aid to China, a relief organization that sought assistance for the war-torn nation. The group sent medical supplies and staff to China, with an emphasis on improving medical schools and training. This building had been the Siam pavilion during the 1939 season.

The American military sent contingents from the army, navy, and marines to the fair where they stayed in a display dubbed Camp George Washington. Fifty members from each service were there at a time to provide demonstrations of military hardware. They also held well-attended parades through the fairgrounds each day.

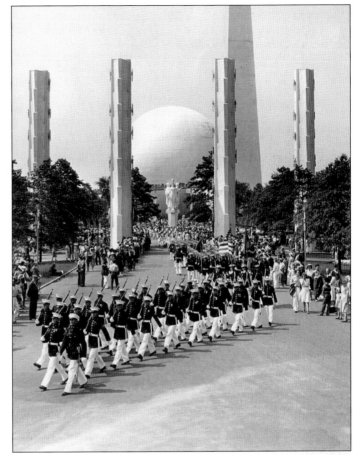

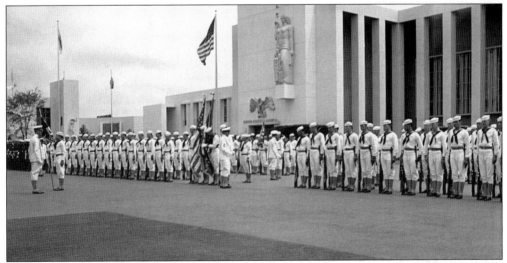

Larger military groups also used the fair as a setting for a variety of ceremonies and drills. In some cases they were there to salute the international exhibitors, while others marked the awarding of medals, promotions, and so on. Most of these displays were held on the Court of Peace, an irony surely not lost on those who were concerned about entering into another war.

Politics turned deadly on the Fourth of July when the New York City Police Department responded to a call about a suspicious package discovered inside the Great Britain pavilion. The bag was carried to a vacant area near the Poland building where it exploded and killed officers Joseph J. Lynch and Ferdinand A. Socha. Suspicion fell on Nazi agents and Irish separatists, but the murders were never solved.

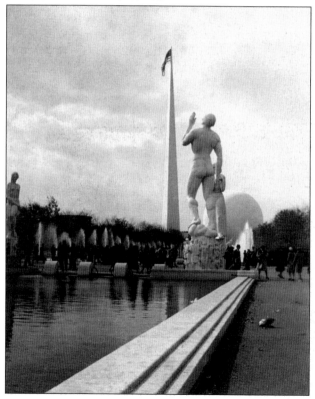

The season's patriotic mood rose, literally, to new heights during the last week of the fair when a giant American flag was placed at the top of the Trylon. The day after this picture was taken the fair closed forever.

All good things must come to an end. The transient nature of the fair can be seen in this view of the Peru pavilion in 1940. Large gray patches have appeared on the building due to peeling paint and flaking plaster. Two years of the harsh New York weather had taken a toll on the temporary building. By closing day some structures had become quite dilapidated.

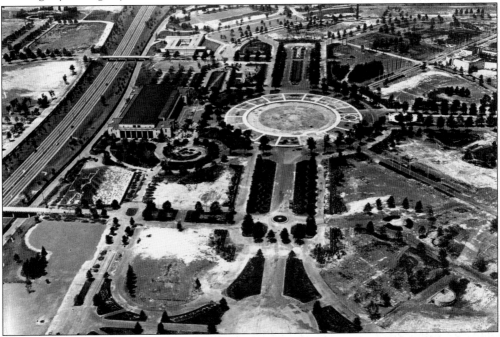

When the fair again failed to attract enough visitors in 1940, it was forced to declare bankruptcy, leaving a long list of unpaid creditors and investors. The financial woes meant that the plans for a new park had to be dropped, and for the next two decades the site languished with empty streets and barren plots where the grand pavilions once stood.

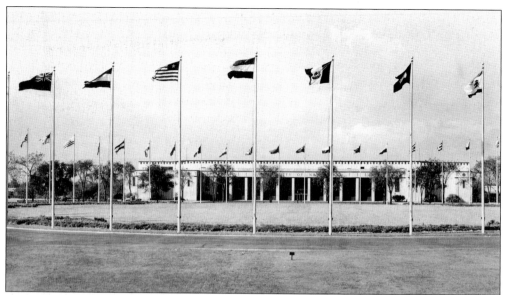

The world returned to Flushing Meadows when the former New York City Building served as the headquarters for the United Nations General Assembly from 1946 to 1951. The building's ice- and roller-skating rinks were covered over to provide a large meeting hall for the delegates.

After the United Nations departed for its permanent site in Manhattan, the building became home to an ice-skating rink, but it stood mostly empty until the 1964 fair. Once again it served as the New York City Building, housing a giant model of the city and exhibits on various government agencies. Today the building is the home of the Queens Museum of Art.

The year 1964 also marked the reuse of the fair's amphitheater, seen here as part of the Florida pavilion. Between the fairs it had been used for public swimming and for music concerts. The amphitheater was later allowed to deteriorate and was demolished in 1996. The amphitheater and the New York City Building were two of the very few pavilions to have been featured in two different world's fairs.

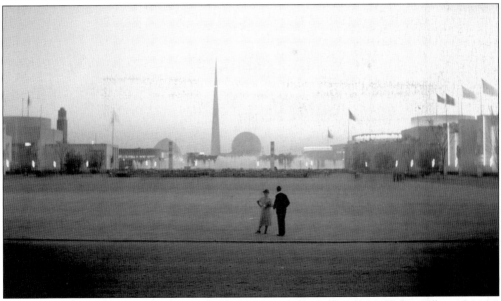

Today the Trylon and Perisphere are but memories, and the predicted world of tomorrow has yet to come to fruition. Was the fair a success or a failure? Those who were fortunate enough to have visited it would more than likely resoundingly vote for success, especially because no fair since has been on anything of the scale and beauty of the 1939–1940 New York World's Fair.

Across America, People are Discovering Something Wonderful. Their Heritage.

Arcadia Publishing is the leading local history publisher in the United States. With more than 3,000 titles in print and hundreds of new titles released every year, Arcadia has extensive specialized experience chronicling the history of communities and celebrating America's hidden stories, bringing to life the people, places, and events from the past. To discover the history of other communities across the nation, please visit:

www.arcadiapublishing.com

Customized search tools allow you to find regional history books about the town where you grew up, the cities where your friends and family live, the town where your parents met, or even that retirement spot you've been dreaming about.

MAP SEARCH